Photography

4 Manuscripts

"Adventure Sports Photography", "Portrait Parties", "Music Business Photography", and "Real Estate Photography"

T. Whitmore

Table of Contents

Introduction

Chapter 1: About Adventure Photography and Lifestyle

Chapter 2: Choosing the Best Sport

Chapter 3: Best Angles and Distance

Chapter 4: Safety

Chapter 5: Gear, Lenses, and Weather Conditions (Oh My!)

Chapter 6: Marketing and Making Money

Conclusion

Bonus Books:

Photography Business—Portrait Parties

Photography Business— Music Business

Photography Business—Real Estate Photography

Copyright © 2016 by T. Whitmore All Right Reserved.

No part of this publication may be reproduced, distributed, or transmitted in any form or by any means, including photocopying, recording, or other electronic or mechanical methods, or by any information storage and retrieval system without the prior written permission of the publisher, except in the case of very brief quotations embodied in critical reviews and certain other noncommercial uses permitted by copyright law.

Introduction

Hello, and thank you for purchasing this book. In these pages you will find the information you need to know about starting your journey as an adventure sports photographer. I hope you find the next few chapters entertaining and informative. Thank you again and enjoy.

Chapter 1: About Adventure Photography and Lifestyle

Adventure sports are the sports that are considered high risk or extreme sports. These are the sports such as sky diving, bungee jumping, skate boarding and much more. These are the sports that you want to follow, but not many people have the guts to participate in. These sports are the ones for thrill seekers and adrenaline junkies to enjoy. There are so many of these sports, and some are not well known. However, even though they are not well known, does not mean that they are not great subjects to be photographed. Quite the opposite really, as the more well-known sports already have a lot of people photographing them. The lesser known sports would give you a chance to shine because you would have a great picture of something that people have not already seen a million times.

This chapter will mention some of the extreme sports that are out there, some of them popular, some of them more obscure, and give a little bit of information on them. Then later on in the chapter, we will go over what the lifestyle of an adventure photographer is like, and how it has ups and downs, but if you

are into fun and thrills, it can be the best thing ever. But first for the sports that you may encounter as an action photographer.

- Blobbing: This is an exciting and rather new sport. It first started as a summer camp activity. However, it soon blossomed into an actual sport. It is done in teams, where the lightest person climbs on the blob at one end, and either stands or lies down. The heavier person on the team then jumps from a good height onto the blob, and catapults the other person into the water. They are judged on height and distance, and you get bonus points if you can do a flip in the air, as that is pretty hard to do.

This is a good sport to photograph, as not only is it fairly new to the scene, it is a pretty interesting sport to capture. There are so many unique shots you could capture that no one else has taken before, such as the unique spread of the jumper's limbs, or the catapultee's form as they are flying through the air. The droplets of water that splash up as the person that was catapulted hits the water. The best part is that you could, if you had a water proof camera, be the catapultee, and capture the image of yourself as you are flying through the air, or as you hit the water. A Go-Pro is best for this.

There are many ways that you can capture these images, and each one of them is thrilling, and a unique experience. If this interests you, get out there and start snapping! (Well not literally, there are still a few more chapters to read, and the rest of this one, but you get the picture.)

- Powerbocking: This is one of the more obscure sports that would be interesting to photograph if you go to the right event. This sport involves people using power stilts to do tricks and flips, and other various dangerous stunts. Power stilts are like pogo sticks and stilts combined, so that you get the spring, but with better balance. It is a fun sport, and can potentially be pretty dangerous if you do not know what you are doing, because there is plenty of risk for injury. However, the injuries are generally not life threatening, unless someone decides to try to jump across sky scraper roof tops, which there is bound to be an attempt sometime if there has not already been a few.

This is a good sport for photographing because it is rather unknown, and it is a very intense sport. There are many action shots that you could take, and there are several possible angles. You just have to know which ones are best, and you will be golden. If you are into

this type of sport, there are several resources for finding angles for a sport where your subject uses jumping motions to propel themselves forward.

- Zorbing: This is a very interesting sport, if you could call it such. It is popular but there are not a lot of competitions that are available for it. However, it makes for good photography. This is a sport that makes you feel like people are hamsters trapped in a skin body. It involves people jumping in giant inflatable balls, and rolling down hills. People have gotten creative with this sport, and have advanced from just racing them, to actually bowling with them, and enacting scenes from movies and video games that involve running from falling boulders.

This is a great sport that you can photograph. You can get the best reactions from people because they are so thrilled, and they are having genuine fun. The best part of this sport is people don't spend months training for it, trying to get every aspect of it perfect, so when you are photographing it, you are photographing pure delight, and entertainment. People are being themselves and having fun. They are not honed, trained machines. They are teenagers, mothers, fathers, and kids. They are families enjoying a thrilling bonding

time. While it is not dangerous, it is an exciting sport that can be considered extreme.

- Scuba Diving: This is a popular sport, and even though it is for recreation and there are no races, it is still a sport and good for adventure photography. Think about it, your subject is hundreds of feet below the ocean's surface with nothing but a tank of air to keep them alive. They are also swimming amongst some of the world's most dangerous and volatile creatures. Of course, to perform this kind of photography, you have to have an underwater camera, and you have to learn how to scuba dive. If this is something that interests you, there are not a huge amount of scuba diving photographers, so it would be a great sport to photograph.

Scuba diving is one of the most beautiful and diverse sports to photograph because every spot in the ocean is unique. Have you ever seen a view of the ocean from underneath? It is breathtaking, and it seems like every time you blink, something is changing. The creatures that you can photograph are amazing as well. There are some thrills such as swimming right past a shark. Chances are you will be okay if you are not bleeding. You do not look like a fish, and sharks don't like the

smell of scuba suits. So snap away dear photographer, as your heart beats loudly in your chest from the fear and excitement of being so dangerously close to something that could swallow you whole. If you are into a thrill that produces beautiful and serene pictures, this is the sport for you.

- Mountain Boarding: This is like skate boarding, only you are going down a narrow dirt pass on the side of a mountain. Extreme, right? One wrong move could result in serious injury, or worse, death. It is not a very well-known sport in non-mountainous regions, but it is pretty popular in the more mountainous areas. This makes it a good sport to photograph, because while it can be popular in some areas, there may not be a lot of photographers in that field. This could be your gateway to success, because then you can make your name in an underdeveloped field, rather than be lost in a sea of submissions in a more popular sport.

Mountain boarding can have some seriously wicked views too. You can get a great shot of your rider coming off a curve, while the background is looking over a city, or a valley. One of the best things about this sport is the view in the background, and the thrill of the subject in the foreground. You just have to know where to look to

get the best possible angles for the best picture you could possibly take.

- Kiting: This is a fascinating and relatively new sport. It involves people attaching a snow or wake board to their feet, and holding on to a massive kite that is designed for this type of sport. Using the wind, they pull themselves along water, snow, and dirt, all while doing flips and tricks. It is like a combination of all of the best board sports, and para sailing without the boat. The best thing about this is that it is a kind of new thing, and does not yet have a million photographers all taking the same picture and trying to get recognized for it.

If you are into the thrill of board sports, but think that you have seen it all before, then this is the sport for you to photograph. With so much versatility in the sport, there are thousands of possible pictures that you could take, and no one has captured them all yet. This is also a thrilling sport to photograph because there are some really close shots you can take if they are doing their kiting on land, such as the boarder jumping over you. This is one of the most amazing angles to capture because it shows that you are right there, and you are a part of the action, and it makes your viewers feel like

they are there and not just looking at a picture. That is the best feeling for an art critic, to feel like they are a part of the picture.

- Barefooting: This is essentially water skiing without the skis. It is a newer sport that pretty much started with "hold my beer and watch this". Okay, not quite, but you have to wonder what was going through the person's head that discovered this could be done. Regardless of what they were thinking, there is no denying that this is an incredible sport. The person who is doing this is literally skiing on water without any thing holding them on top of the water except a rope and inertia. The tricks they perform are amazing as well, because they are not burdened by long and awkward skis like regular water skiers. This makes it a lot easier to capture, because you don't have long wooden or titanium sticks blocking your shot, and there are no awkward shadows to edit out.

This is a great sport to photograph if you like water sports, as it is kind of new, but is well known enough that while you can get your name out there, you can also be sure that there are going to be a lot of people who want to see your pictures. This means that not only will you get your pictures out to sport fanatics, but also to regular civilians who enjoy looking at photos of

sports. You can also get some great angles if you are behind the person or in front of the person on a boat. You also get a clear shot of your subject so no matter what tricks they do, you can properly showcase their abilities.

- Parkour: If you see people randomly running and jumping on things, rather than just going around it, that is parkour. It is literally a sport that involves jumping over as much stuff as possible. The actual definition is moving through obstacles as efficiently and swiftly as you possibly can, but it is literally just an excuse to act like a monkey and show off to your friends. Regardless, it is a pretty adventurous sport, and involves a lot of gymnastic ability. It is great for photographing as well.

You can get the best angles with this sport, because you can stand almost anywhere to get a good shot, and that is what you want to be able to do in photography. This is a key in any good sports photography, and that is to be able to get a good angle, and you don't have to worry about that with this sport, because it is so interactive, that you could literally stand underneath the person and they will just jump over you.

These are some of the lesser known sports. These are the best for you to get into, because they are the sports that not everyone will be photographing, and you can take some pictures with angles that haven't been done a million times over. This is best for someone who wants to be unique and start their own trends. However, the downside is that since they are not as popular, there may not be a lot of viewers for the photos that you take, so you will have to work extra hard on marketing.

There are more popular extreme sports out there that you can get into. You will have to bring something new to the table though, and that is a lot harder in a popular sport, because there are so many people vying for the same spot that you are trying to get. However, there are a lot of viewers of these sports, so marketing will not need to be near as aggressive. This gives you more time to focus on getting the perfect shot, and maybe making your name in the industry a lot easier than it would be if you had to market yourself aggressively. It all depends on what you prefer. If you prefer uniqueness, then a more obscure sport is probably best for you. However, if you want to shine in a sport that is well known, then a more popular one may be what you are looking for. This is your choice, and here are some of the more popular sports that are out there

- ☐ Water skiing: This is a sport that involves long wooden or titanium planks that hold a person up on the water so that they can skim across it at high speeds. They are pulled along the water using a rope that is attached to a boat. The most extreme skiers use the wake created by the boat to do tricks, and do a type of surfing, called water boarding. (Not the torture, the sport.) Water boarding is the same concept as water skiing, only you use something that resembles a snow board rather than skis.

 This is a good sport for photography because you can get some pretty cool pictures of people doing some intricate jumps and flips. Be careful however, because the board or skis can create a shadow, or block your subject altogether, so you have to really focus on getting your timing perfect to get the perfect shot.

- ☐ Solo Climbing: This is an insane sport, and photographing it can be tricky. However, it brings a great thrill because you could literally see your subject doing the most life threatening thing on the planet. However, it is also terrifying because if they do not have the grip of death, then they easily could fall to their death. These people are the most intense of any athlete, and that is what they are. Athletes to the core, because

it takes a lot of practice, time, and effort to be able to free climb. This sport involves the athlete scaling the side of a mountain without any safety gear. They literally rely on their own grip the entire way up, and sometimes the grip holds are literally only big enough for fingertips. While this is an adrenaline infused sport, it is not for the faint of heart, because you have the chance of seeing something very gruesome that you probably could go your entire life without seeing.

However it is a great subject to photograph, because while it is insanely popular, there are not a lot of people who are willing to photograph it for fear of seeing their subject fall to their death. If you have a strong disposition, then you could be perfect for photographing this sport.

- Bungee Jumping: This is one of the greater known extreme sports, and it is a thrill for all that experience it. There are plenty of photos of bungee jumpers though, and as there are not many angles that you can photograph from, it is best to avoid this sport when starting out.

There are some of the more popular sports, plus one that you would do well to avoid, unless you are going to try something

that has never been done, which would be photographing someone on a double jump.

Now on to the lifestyle of a sports photographer. These people are some of the most thrilling people there are because they put themselves and their safety on the front lines. They are literally in the path of some of their subjects which could get them seriously injured. So to be a sports photographer, you have to be a thrill seeker yourself. If you are a thrill seeker and an adrenaline junkie, this could be the job for you.

There are several things that you need to remember when you are a sports photographer though. The first is that no matter how much of a thrill seeker you are, your safety should never be on the sidelines. No shot is worth your life. A lot of times, sports photographers get so addicted to how thrilling it is to have near misses, that they push the envelope farther and farther, until eventually they slip and get injured, or worse, killed. If you are able to keep your safety in mind, you should be able to do just fine.

Secondly, you should always remember that the gear makes the person. Later on in the chapter, we will discuss different things that you could need as an action photographer. You want to be able to get all of the action, no matter the weather conditions, or the angles that you have to be able to get. If you

do not have the right gear, you could miss out on what could be potentially the winning shot, and that is not what you want to do.

This is a dangerous job, so do not try to get into it if you are not prepared to put yourself in some dangerously tricky situations. Because no matter how many safety precautions you take, some of these sports you will be capturing can be unpredictable, and to get the perfect shot you have to put yourself on the front line. If you are willing to do this, and enjoy it, this could become a life career.

Lastly, have fun. There are so many opportunities for you to get out there and enjoy yourself. You are not going to get the perfect shot by standing on the sidelines trying to coordinate everyone. You get the perfect shot by getting out there and getting involved. This is not a profession where you can control everything. If you are looking for that, you might want to try portrait photography. However, since you are reading this book, there is a high chance that you already know that this is an unpredictable profession.

In photography, most people who are not photographers feel like it is an easy profession. This is not true, you have to capture the essence of people in a still frame. This is easier said than done, because humans are naturally moving. This is even more of the case with action photography. You are

literally trying to capture the moving world in a still photograph. If not done properly, this could turn into a blurry indistinguishable mess. You are the difference between a masterpiece, and just a simple picture. You are the artist, and that in itself is a lot of pressure. Not to mention the high pressure life of adventure sports and action photography.

That being said, this life isn't all bad. There are a lot of perks, and we aren't just talking discounted tickets to the biggest sports events in the world. We are talking personal perks such as the thrill of being so close to, or part of the action. The joy you get seeing people act out their passions. The recognition you get from your photos is unrivaled by anything other than the thrill of the near miss you had when you took that photo.

This is a life of thinking ahead. You have to plan in advance, which means that you have to know the sport that you are photographing. That way you can be in the right place at the right time. You cannot rely on luck in this profession. While it is a contributing factor, you also have to be able to put in your own effort to keep things safe, and to get the best type of shot. You have to plan ahead with angles, gear, and with your own stances. You want to follow the action and simultaneously be ahead of the action. Since there are not two of you, you have to plan accordingly. This is a very intellectual profession due to all of the planning. It is like you are engineering a photograph

except you are not simply pressing a button. You are conducting a symphony within your camera of light, shadows, shutter speeds and depth. There is so much you have to think about at one time, while also focusing on the action at hand to time everything just right.

Life as a sports photographer is also busy. You often have to go to several events in your chosen sport(s) to get the shot you need. You could take a hundred shots at any one event, and while they might all be of good quality, none of them are the money shot. This is a real possibility. You have to always plan to go to at least ninety percent of the events that are scheduled for a season in your sport. This means a lot of travel, and a lot of time packing and unpacking gear. Most of the time you will only get one or two great pictures, but those pictures will be what earns your bread for the season of that sport.

You are literally creating what some people could never even imagine. You are creating a separate reality for your viewers. In this reality, everything is still, calm and perfect. Yet you can also feel the chaos and the thrill. You can definitely change someone's perception of a sport with a photograph. You can show someone the gruesome truth, and the beautiful honesty of that sport. You can create a whole different air about you that is totally separate from your real life. You can live in the most serene place in the world, but lead people to believe that

you have a loud, thrill filled life, when in reality that is only a small glimpse of how you spend your time.

There are a lot of times where you work long hours without a break though. You don't want to move for fear of missing "the shot". This means that you often miss meals, and that you are tired when you finish. However, if you get that perfect shot, then it makes it all worth it. You get dirty, you get sweaty, you get hot, and you get cold. You have to deal with the elements and the noise. Then you have to tote your heavy camera bag everywhere. However, when that paycheck rolls in, no matter how much you were cursing the day before, it makes it all worth it.

Sports adventure photographers are the ones that take the photos in the sports magazines. When you see a photo of a NASCAR race, it was a sports photographer that took that picture. There are so many pictures out there of sports, and they were all taken by people of your profession. Each of those photos has a story, and each of those photographers has a life. They are all joined together through the lifestyle of sports photography. The hard days, and the cold nights. The long hours they put in, and the hundreds of shots they took until they got "the one". The lifestyle where you put your safety on the line every day alongside the athletes, just to bring entertainment to the world of people who could not get to the

event themselves. For these people, it is not about the money. It is about bringing the joy they feel when they enjoy these sports into the hearts of others. It is about translating the emotions they feel into one still shot. It is only having one shot to tell an entire story. That is the lifestyle of a sports photographer. It is more than the people that they meet, and the places that they get to see. It is more than the fancy camera, and high end gear. It is the work and the passion that they put into it to get to where they are now.

Imagine the best story that you have ever read. For example, let's use the Harry Potter series. It is a series that most people know, and most of today's generation grew up with. It is a favorite of many, because it puts joy into people's hearts, and gives them a tale of magic and wonder. They feel they get to learn and grow throughout the books and with the characters. There are millions of words that are read to translate this story, and it spans across seven books and eight movies.

Photographers are telling a story as well, the only difference is that they are doing so with one photo. They do not get a bunch of rough drafts. They may take a thousand photos, but they can't edit them to get the money shot. The best photos are raw. So in reality they only get one shot to tell the story in that moment. That is what you are going into, and it is a truly wonderful and heartbreaking thing. Wonderful because you

can tell a story with so little information, heartbreaking because of all of the attempts that it takes. It can be discouraging at times, but never give up, because it is all worth it once you have that one picture that tells your story, and you are able to share it with the world.

So that is the lifestyle of the action photographer. If you think that you have what it takes, continue reading to find out more about lenses that you should be using, safety precautions that you should take, gear you should use, and angles that will make your shot the one everyone wants to buy.

Chapter 2: Choosing the Best Sport

It is no secret that if you do not choose the right subject then you are going to not be the best at the photographs you take. You have to know the sport inside and out to really succeed. This means you should choose something that you are interested in. Something that you are willing to learn more about, and take some lessons in, so that you can really think like the athlete in order to get the perfect picture. You also have to choose a sport that fits within your range and budget. If you are in grassland, unless you have the finances to travel long distances, you might want to stay away from mountain sports.

When you are picking out your sport there are a few things that you should remember, as you want to pick a good one to capture that also fits your parameters. This is pertinent, as you could be picking your favorite sport, but it is not as unique as you would like, or it costs too much to follow. So following these tips will help you choose the best sport for you.

- ☐ Find What Clicks: First off, find the sport you want to follow the most. Whether it is a water sport, a dirt sport, an air sport, or a snow sport etc. You have to find one that you would be willing to train in, and one that you

would be willing to put in a lot of hours researching. Once you find this sport, it is time to look more into what it takes, to make sure that it is the right choice for you. It is best to find a few sports so you can narrow it down.

- Research: You have to look into every aspect of this sport. Not the training part yet, though that is important. You need to research the gear that you will need and the safety precautions that you will need to take. The things that you need to make a masterpiece. Also you have to research schedules for the events, and how far away they are to see if the sport is a viable option for you.

- Budget: Make a budget. Tally up how much disposable income that you have to get you started, because to start this business you have to have some money to buy equipment and to get into events. A few might let you in free, but that is coming up. You also have to plan for travel expenses. Prices of fares, gas, rental cars, hotels, and the list goes on and on. If you are just starting out on a tight budget, you might want to start closer to home.

- Research some more: Look into the events that you

would like to go to, and call to see if the hosts of the event would like to make a deal. Be careful with these though, because even though you could get free tickets, you may have to give up the rights to your money shot for free. Not all event hosts are like that though. Some are kind, and they keep your name attached to the photo, they just want permission to put it up on their website.

- ☐ Finalize the Sport: Once you have decided on which sport works best for you, it is time to start learning more about it. Maybe take a few lessons, and read as much as you can about it. Really try to get into an athlete's head, and try to think like one. This is the best way to really become a great sports photographer.

Of course there are some sports that are better than others, and some are hot on the market right now, while others are not. You may want to learn more about a few sports so that you can have some work even on the off season of your chosen sports. Plus variety is always good to have, as it will help get you some recognition a lot faster.

Some of the best sports to focus on right now are things that are just coming into popularity, such as parkour, or barefooting. These things are quickly taking up precedence in

the sport world, and you should get in there while the press is hot on them. You can get recognized in a developing area, and not have to fight for a spot in the spotlight.

Why You Should Choose a Newer Sport
The sports that have been around for years already have seasoned pros taking pictures at those events, and the angles have all been seen before. People want to see something new, and they want to see something that is relevant to their lives. The newer sports that are coming into the light are what are catching people's attention right now. You want to be where the people are, not where they used to be, and not where they may be in the future. You want to be in the here and now. That is why sports that were mentioned in the first list in chapter one are the best sports to start out with, because you can grow with them.

There are so many perks to choosing a newer sport. For example, the barrier of entry to a new sport is a lot easier. That makes it easier to get your name known. A lot of the events are cheaper, some even being free aside from travel which makes it great on the budget of a beginner. Choosing a newer sport also gives you the ability to showcase your unique talent, because people are really going to be looking at all aspects of the photo rather than just looking for the wow factor. In sports that have been around for a long time and that have been

photographed a lot, you are not relying on skill anymore, you are relying on luck to get that shot that no one has seen before, but with a newer sport, it is skill that you are relying on. And the critics are going to be looking for that. They will be interested to see new techniques and new content, rather than burnt out on yet another photo of a skydiver jumping out of a plane. You have a better chance of making it in this career if you do choose to follow a newer sport.

That isn't to say that you have to choose one from there, there are a lot of other up and coming sports out there. And you can choose an older sport. If that is what you are attracted to, then follow your heart. You are not going to get a good photograph if your heart isn't in the game. Find more ideas on sports to photograph at https://iso.500px.com/a-day-in-the-life-of-extreme-actionsports-photographer-tristan-shu/

Chapter 3: Best Angles and Distance

In photography, the best pictures are the ones that have the perfect angle, and that are the perfect distance from the subject. As a photographer, you have to be the one to make the decision on where you want to be, and what distance you want to be at, or appear to be at. This will determine your stance, and how close your subject looks to be to you. You also have to decide what you want the picture to feel like. This determines the angles you use. Everything is tied in together. That means that you cannot go on to the next step without making a decision on the current one you are on.

When you want to get the best angle, there are a few tips that you should remember. These tips will help you choose the angles that you want, and help you get the picture that will make your name in the books.

- ☐ Feel: You have to decide how you want the picture to feel. This will decide the side you want to approach the subject from. If you want it to feel heroic, then you will shoot from underneath, if you want it too feel humble, then you shoot from above, and so on and so forth. The

spot you choose to shoot from will determine the feel of the picture, and vice versa.

- Remove fear: Too many photographers are afraid to shoot from certain angles, because they have been told that they are photography no-nos. The best example is shooting from underneath. Photographers are told that this elongates the subject too much, and that it should be avoided. However, in action photography, it is a great angle to shoot from, because it gives the picture a really deep and emotional feeling. Stop fearing angles, and get out there and try something new.

- Let it happen: Don't grip so tightly to an idea that you lose the perfect picture, because you didn't want to use that angle. You have to be willing to make on the fly changes to your approach to get the picture that you want. Sometimes you may think that you want one angle, when in reality, you need one that is almost opposite. This is much different than portrait photography, where you shoot from the angle you want to shoot from, and make the subjects move where you want them. In action photography, you have to shoot where the action is. The picture does not come to you, you have to go to it.

- Have fun: You have to have some fun with your angles. Take a picture from a few angles that you feel won't deliver a perfect picture. You may be surprised at how good the photo actually turns out. If you loosen up and have fun with your angles, then you will be able to get the shot that you need.

Angles are an important part of photography, so while you should have a general idea of the angle that you want, you should also be willing to change your plan up. Especially in action photography. Most sports are so unpredictable that you have to make a lot of decisions on the fly. That is okay. All you need is knowledge of the angles that are available, and how to achieve them with the camera that you own.

Distance is a whole new ball game though. It is very important that you know the distance that you want to be from the subject. Not only from a photography aspect, but also from a safety aspect. While a close up, wide angle shot may be desirable, it may put you in the danger zone. That is the area that you want to stay away from. The danger zone is where you put yourself at risk, along with the possibility of putting your subject at risk as well, as they could hurt themselves trying to avoid you.

There are a few things that you have to remember when you

are trying to decide the distance that you want to be from the subject. These tips are not law, but they are good guidelines to follow if you are not sure where to start on finding distance.

- ☐ Know your location: This is important. You have to know where you are going to stand, so that you can ensure that spot will be open. Spectators do not like to move, even for a photographer, and you could find yourself having a hard time getting to your desired spot, potentially missing out on some good photos if you are not already there. It is always best to show up early enough to find the best place for the action. If you do not scope out the area, you could miss out on the best spot.

- ☐ Stay out of the danger zone: Unless you are a seasoned pro, the danger zone is not for you. Try to stay as far away from it as you can while still getting a good shot. This is important, because some danger zones could cost you your life. Especially at something like a NASCAR or Indy 500 event. Other danger zones can get you seriously injured. So it is best to stay away from them if at all possible.

- ☐ Shadows: Always make note of where your light source is going to be at any given time. If you don't, you may

have a good shot of the action, but it could be ruined by a pesky shadow that is out of place, obscuring a very important detail in the photo. Shadows are good on some photos, but you want to try to keep them in their desired positions. So always take shadows into account when you are in a location.

- Width: How wide do you want the shot? You have to decide how wide you want it to determine how close you have to be to the subject. The wider you want the shot, the closer you have to be at more of an angle. When making this choice, always keep the danger zone in mind.

Those are just a few things to remember when you are choosing your distance from a subject. Again, you can omit some of these if you have better tips, these are just a guideline. But above all, know your subject, and don't be afraid to play with distances. From spectator distance, to close ups, the possibilities are endless, and they all can deliver some really good shots.

Chapter 4: Safety

This chapter may seem a little repetitive not only on itself, but from things stated above, but that is because safety is of utmost importance. As mentioned above, no shot is worth your life. This profession is not a desk job, so often there is no insurance that comes with it. You have to take your own wellbeing into account. Too many times these days you see sports action photographer putting themselves in harm's way just to get the perfect shot. This is not okay because a lot of times when you are putting yourself in harm's way, you are also putting other people at risk. Not only the athletes or your subjects, but anyone who may be brave enough to try to save you as well. You always have to keep safety in mind, and do not pass those mental lines.

Safety has become a hot topic as of late, and a lot of seasoned pros will say, "the danger zone doesn't exist. Look at me, I'm still fine." In reality, these people are just lucky. They have been graced to have not been injured, or worse, killed while they are disregarding safety precautions to get a good shot. I recently watched a video where a photographer was at a NASCAR race. He was on the edge of the tarmac at a corner

where wrecks were common. He had a foot on the pavement and sure enough, two cars came screeching around the corner. One of the cars lost control and smacked into the other missing the guy by mere inches. What does he do? He finishes taking the pictures, unscathed, and walks away. I know after a few years you get used to the thrills, but such a blatant disregard for general safety is a big concern.

You have to be concerned with safety at all times, not just when it is convenient for you. You have people that care about you, and how would they feel if you got hurt on the job and it could have been prevented if basic safety measures were taken? Not trying to cause a guilt trip, just pointing out the severity of not being safe. This job is dangerous enough without added problems from disregarding personal safety.

Bottom line is that the danger zone does exist, and you would do well to remember that. If you are in an area where you could very easily get killed, and it is not going to be a one in a million hit, you should stand elsewhere. If you are in the middle of the action, and could get seriously injured, you should stand elsewhere. Unless you have already warned the athletes or other subjects of your photos that you are going to be in the middle of the action, stay out of the way. They could seriously injure themselves trying not to hit you, when you just wander into their way trying to get a good picture. Some places

will even ban you from further events if you do not get an okay to stand in the danger zone. That is because safety is so important. It is the reason it has a whole chapter devoted to it.

There are a few tips that you should remember when you are photographing the events that you are at. These tips should be considered the holy grail of tips until you are experienced enough to figure out your own. If you have a friend in the field and they have some better suggestions, by all means go ahead and follow those too, but for now here are some general tips.

- Gear: You should always have the proper gear with you. Not only protective gear, but also camera gear. In another chapter we will talk about some things that you may need, and why gear is so important. But it is also important when it comes to safety, because you don't want to have to risk your neck trying to keep your camera safe.

- Clothing: You have to have the right clothes for the weather conditions. You do not want to be wearing shorts in the Swiss Alps and a fur coat in the desert. Clothing will keep you from getting ill due to weather conditions, so make sure that you pack accordingly.

- Mind the Danger Zone: This is a real thing, and you

should do well to keep in mind these zones. If you are unsure of where they might be, ask around. Safety is the number one thing, and you do not want to be standing where you could get yourself or someone else hurt.

- Limitations: Keep in mind your own physical limitations. You do not want to be doing something that is beyond your physical capabilities, otherwise you could get seriously injured. If you are not good at free climbing, and your subject does not want a photographer using ropes, maybe find a different subject, because your safety is the number one priority.

- Condition of Safety Gear: Lastly, make sure that your safety gear is up to code. If you are scuba diving, you do not want your hose to be old and cracked. You have to make sure that all of your gear is ready to go each season, and that you are going to be safe when you go to take pictures. Inspect each piece of gear for wear and tear, and make sure that you have everything that you need.

The safety of yourself and others around you is the most important thing of all. You have to make sure that you are where you need to be and that you are taking the precautions that you need to take. Safety is above all else, the most

important thing.

Another thing to remember is to follow the athlete's lead. If they are leaning one way, then you better lean that way too. Especially if you have to be in the middle of the action. They can see a lot more than you will be able to looking through that viewfinder. This is a mistake a lot of rookie photographers make. Sometimes you have to look away from the viewfinder. Pay attention to your surroundings and make sure that you are safe. You cannot see everything if you are looking into a tiny box at a specific target.

Above all, use your common sense. If it seems dangerous, or like it could be bad if it is not done right, and you are not sure how to do it. Don't do it. This shouldn't have to be said, but the amount of photographer injuries states that it should be said. It is not meant to be an insult to your intelligence, merely a reminder not to get so caught up in the moment that you lose your head. Quite possibly literally.

Chapter 5: Gear, Lenses and Weather Conditions (Oh My!)

This chapter is kind of a catch all of information. These are good together, as a lot of them tie in together, so here they are. Together. Have we said together enough? Yeah? Okay.

Anyways. It is very important to have the right equipment for when you are trying to get a great shot, and you need to know what weather conditions are right for shooting. Here you will learn the basics of what you need, and what determines what you need to be a success. Also we'll discuss how to handle weather conditions and know when to take cover, because a lot of athletes will not stop for anything unless they really have to. Unless you are that extreme, it is best to keep yourself and your equipment safe so that you can continue doing what you love at a later date.

Lenses
Let us start with the best lenses for this profession. You want lenses that will give you clarity both close up and farther away. Image stabilization in the lens is a bonus, but it is not required

for a good shot if you have a steady hand. There are good lenses for beginners, and there are lenses that are good for pros. Since this is a book geared towards beginners we will stick with those. The first thing that you have to think of is what type of camera you want. Do you want a standard DSLR, or do you want a mirrorless interchangeable-lens compact camera?

A DSLR is what you would generally think of when you think of a camera. It is the big professional camera that you can attach a telescope lens to, similar to the ones you see on the sidelines at a football game. It is the type of camera that most standard photographers use. The only downside is that it can be heavy and bulky, and is not great for places where you need something light and compact.

A MILC is a compact camera that you can change the lenses out like on a DSLR, but it is small and versatile. You have the ability to maneuver it around a lot better without the bulk and without the weight. Shutter lag is almost nonexistent with the newer ones, and they are quickly over taking the DSLR market. However the aperture is generally a lot smaller so you have to raise the ISO considerably.

Both are good options for the sports photography, however, the choice that you make will drastically influence the lenses

you buy because you have to buy different types for different cameras. Also, lenses change from camera brand to camera brand, so you have to find what works best for your particular camera.

If you are just starting out, and let's assume that you are, you will probably want to buy a kit lens. These lenses now come with built in image stabilization and they are great if you are trying to learn the basics. If you are making this a profession, then you have probably had instruction on the different types of lenses and what they do, so it is just a matter of choosing the right one for the job.

There are a few tips to help you figure out what lenses you will need to do the job well and get the best shot. These tips do not lead to a certain lens itself but are things to think about when you are trying to choose a lens. If you follow these you should be able to choose the right lenses for what you need.

- Distance: You have to keep in mind the distance you are going to be from the subject. This will tell you what type of zoom, and what type of resolution you will need. If you are trying to capture close ups, then you will need a lens that is good for wider angles. It all just depends on how far you need to be from your subject.

- Angle: The angle is important when choosing a lens as well. If you find yourself constantly using a certain angle, go for a lens that is compatible with that angle, and makes shooting it a lot easier. Look for size, zoom, and resolution to get the best shot possible.

- Background: Believe it or not, the type of background style does affect the lens that you need. Some are better for clear background, some are better for a soft background, and some are better for a super blurry background. Take into account the type of pictures that you want to produce and what you want the background to look like. Use this knowledge to choose the lenses you need.

- Subject clarity: How clear do you want your subject? And before you say you want them to be really clear, what if you do not? Sometimes the background is the most important shot you can get. It all depends on what is going on that day, and what you want to get. Make sure that you have a lens that will focus on the background more than the foreground, even if you only have one.

- Specialties: Do you have special camera tricks? If you do you might want to make sure that you have a lens

that can do what you need. A lot of people try to adapt their lenses that they have currently to fit their needs to save money, and while that may work sometimes, a lot of the time, you need the right lens to do the job. Otherwise you are not really that much different than a hobby photographer.

Find a good group of lenses. Most people have three or four, but real photography enthusiasts have more than that. The most important thing is that you find the ones that suit your needs and you use them well. However, you should also use them in the way that they are meant to be used. Adapting your lens to try to get a different shot could ruin the lens entirely. Stick with its original purpose, and when you have the finances, buy the one you truly need. You will save money in the long run.

Once you have found your lenses, you can begin to set up a plan for when you are going to use them, and what shots you are planning on taking with them. Don't set your plans in stone though, because you may have to change them in a moment's notice.

Gear

Now it is time to talk gear. If you are looking at your bank account saying "what am I thinking?" relax. You often can find

this stuff online for relatively cheap. You do not need the most expensive brand of equipment, just make sure to check the reviews to ensure that you are getting quality products for your money. Stay away from gear that doesn't have reviews, because that in itself is a bad review. You can find the best deals on places like www.ebay.com or www.craigslist.com if you look hard enough.

Now that you have gotten over the mental crisis and momentary self-doubt that you may have just had, let us move on. There are some things that are important to have, and some tips to know what else to look for. However, you do not have to get everything on this list at one time. Just be prepared to do some extra things to ensure camera and physical safety when you are out shooting without them.
Here are some of the gear pieces that you will probably need.

- You will probably need a sturdy camera bag if you do not already have one. A lot of people use a backpack, but those are not protected enough. There are special bags with reinforcements in them to help protect your camera and lenses from damage, and keep the bag from ripping under the undistributed weight. You will probably want the backpack style one, as they are the easiest to transport in tight places. The best ones to get have extra padding on the straps, and waist clips so that

you can distribute the weight better. Not only that but waist clips are also awesome because they make it harder for people to steal your bag.

- Tripods are a must. You should have a few different ones for different shots. They make sure that your picture is steady so an adrenaline rush does not make your hand shake. Of course, there are places where a tripod doesn't work, so you have to know how to keep the camera steady without one as well, but in places where you can use them it is always great to have them. There are several different types to consider. It is best to have a small one for when you are trying to get a low angle. You should also have a medium sized one for a general angle and a tall one for a high up angle. These tripods will help you get a clear shot every time you need one.

- Lcd loops and electronic viewfinders are a big help so that you can see the shot without having to beat the glare of the sun. There are several types out there, and you can buy many different types for cheap. These help you ensure that you are getting a good shot, and there is no guess work involved. These are not a necessity, but they do help out a lot.

- ☐ Something that can save your camera and preserve it for years to come is a real and reliable rain guard. A lot of people use trash bags, but these are not meant for cameras and often do not cover everything. Sometimes they even cover too much, making it difficult to take the shot without exposing your camera to the elements. A real rain guard will be custom made to fit your brand of camera, and they will protect your equipment from the elements while still making them easy to use. They are definitely worth the cash up front, and should be one of the first things you buy, because you never know when the rain is going to strike.

- ☐ This is probably a given, but you need a good camera. There is no specific brand, just make sure that it has good reviews and is reliable. It should have a frame speed of six frames per second or more, and have a continuous mode. This makes it a lot easier to shoot high action clearly. It should be easy to use so you can make adjustments at a fast pace. Having a good camera is the most important part of this profession. The most affordable of the recommended brands tends to be Pentax. This is a brand that is affordable and reliable, coming in at half the price of a Nikon or Cannon camera of similar specs.

- Remote cameras are again, not a necessity, but they are a huge help for when you want to get close to the action without being in harm's way. They are not cheap though, so they would take some saving for if you do not have a lot of disposable income. With a remote camera, you can get in places where it would be too dangerous for you to stand yourself. Such as right on the edge of the track. Just set it up, and use your remote to take the picture at the right time from a safe distance away.

Those are some of the gear items that you should have in your bag. Some are a major necessity, some are just really helpful to have. You can decide for yourself what you need, although don't forgo the rain guard. When you are choosing gear make sure you have what you need for your particular sport. Oh, yeah, don't forget. You need a rain guard. Okay, all joking aside, gear is important. Outsiders do not realize just how much you really need to be a photographer. They think you just pick a camera, point and shoot with any old lens, and BAM, instant fame. This is not the case. It is all in the lenses and gear that you have.

Weather
You have to know how to handle the weather to be a good photographer, and you also have to know the general weather

of the region in which your sports are generally located. If you know the weather patterns, it makes it easier to prepare for it with clothing, gear, and a shelter plan if necessary. You should also have a first aid kit in your bag at all times. Not part of the weather, just a necessity.

If you are in an area where tornadoes are common, it is best to go with a plan of action to ensure that you can be safe, even in the event of a tornado, because some places schedule events even if there is a tornado warning in the area. Some places don't, but a lot in tornado alley do. Find a shelter that is close enough to get to in case of a little warning. Have a packing plan so that you can get your gear torn down and packed in a quick swipe. And lastly, run if required.

If you are in a place where it is very snowy, make sure that you have a warm coat to prevent getting sick, and make sure you have an insulated weather guard to keep your camera from freezing if it gets that cold. If you are in an area where it is slippery, make sure that you have ice cleats so you do not fall and injure yourself. Snow shoes help as well if you are in a powdered snow area.

If you are in an area where flooding is common, bring an inflatable raft. Seriously. A lot of them can be folded into something that can fit in your bag easily, and they do not

inflate until you open them. Also, have a plan to get rescued if you do get caught in a flash flood. If it only rains then make sure to use your rain guards that you have probably purchased by now.

If you are in an area where fires are common, then you should probably have a plan of action to outrun the fire, or stay out of that region, because fires don't mess around. However, if you do find yourself in a situation where a grass fire starts and gets out of control at your event, it is best to have an escape plan. You probably won't keep a fire extinguisher on you, but a few clean rags to breathe through are a good idea.

Weather can be volatile, and no matter the amount of planning that you do, you can still find yourself in a situation that you were not prepared for. The best thing to do is keep calm, and clear your head. Use common sense, and do not put yourself in a dangerous situation, even if it means harming your equipment because you cannot pack it up fast enough and have to leave some behind. Items can be replaced, even if they are a little expensive. That is what insurance is for. You have to think of your safety above all else. You cannot put your equipment above your physical being, and if it is you or the camera, choose yourself because the camera can be replaced, you can't.

Here are some tips on handling the weather if you are not quite sure what you should do in the case of a storm of sorts.

- ☐ Ride it out: If the storm is not too violent, try riding it out. You do not want to miss out on a good shot just because it is raining or snowing a bit. That is what rain coats, umbrellas, and rain guards are created for. If it is just a mild storm, continue watching the action with your protected camera, and focus on getting a good shot. Just keep an eye on the storm and look for worsening conditions.

- ☐ Watch the crowd: A lot of times, if a crowd is gathered, the event hosts will not stop the athletes, no matter the weather, unless it becomes a physical threat to them. They wait until the crowd starts to disperse, and then they will decide to stop the event, or delay it till the storm passes. If the crowd starts to thin out, you should probably follow, because if it is bad enough for spectators to disperse, then that means it is getting pretty bad.

- ☐ Keep Safety in Mind: If it is getting too difficult for you to remain safe while trying to take a picture, then you should probably head to a safe place. You may not have gotten the shot you wanted, but you can always try

again at a later time. Safety is the number one concern in inclimate weather. You have to make sure that you are doing what is best for you, so that you can continue doing what you love for years to come.

- ☐ Leave When Instructed: If you are instructed to leave and seek shelter by someone, then it is best to heed the warning. Don't try to get in one final shot, leave. It may be a beautiful picture, but safety is the most important thing that you need to think about. Not a photo, not your gear, your safety.

Those are some safety tips but remember, just because weather is volatile, does not mean that it is not beautiful. Do not be scared of a little mild weather. You just have to know when to take shelter. If you can get some weather elements in a picture safely, go for it, because it makes a picture all the more unique. Whether it is rain, snow, sleet, fire. Anything that you can have to add another element to your picture will up its value in the critic world, and that can boost your name. Just keep safety in mind and you should do just fine.

Chapter 6: Marketing and Making Money

If you are going at this solo, and not through a company, then you are going to have to market yourself. You do this by putting your pictures out there for the world to see. There are several ways to do this, you can post them on social media, which is free. You can send them out to various companies, which will cost print fees and postage. You can also find someone to promote your photos for you which would also cost a fee. A personal favorite here is social media. It is free and can reach thousands of people instantly. All you have to do is share it. Be sure to water mark it though, because putting it out there can tempt people to steal unmarked work and mark it themselves. Instagram is a very popular platform where you can share and hashtag people who may take interest in your photos. Over time you will organically grow a following allowing you more opportunities to monetize your photos and talents.

You will make most of your money through selling your pictures. Attending various sporting events will also allow you the opportunity to network with event planners. Create

relationships with these people so that eventually they may pay you to be their official photographer at upcoming sporting events. It is not an instantaneous process, but it can bring you in a lot of money in the long run. Make sure that you are getting paid enough to cover your cost of travel, food, and lodging, etc. Otherwise you are not really making money at all.

Conclusion

Thank you again for purchasing this book. I hope that you enjoyed the contents you read, and found that you were given information in an entertaining manner.

If you like the book, please leave a review on Amazon. Thank you!

Photography Business

How To Make Money And Grow Your Business With Portrait Parties

T. Whitmore

© **Copyright 2016 by T. Whitmore - All rights reserved.**

This document is geared towards providing exact and reliable information in regards to the topic and issue covered. The publication is sold with the idea that the publisher is not required to render accounting, officially permitted, or otherwise, qualified services. If advice is necessary, legal or professional, a practiced individual in the profession should be ordered.

- From a Declaration of Principles which was accepted and approved equally by a Committee of the American Bar Association and a Committee of Publishers and Associations.

In no way is it legal to reproduce, duplicate, or transmit any part of this document in either electronic means or in printed format. Recording of this publication is strictly prohibited and any storage of this document is not allowed unless with written permission from the publisher. All rights reserved.

The information provided herein is stated to be truthful and consistent, in that any liability, in terms of inattention or otherwise, by any usage or abuse of any policies, processes, or directions contained within is the solitary and utter responsibility of the recipient reader. Under no circumstances will any legal responsibility or blame be held against the publisher for any reparation, damages, or monetary loss due to the information herein, either directly or indirectly.

Respective authors own all copyrights not held by the publisher.

The information herein is offered for informational purposes solely, and is universal as so. The presentation of the information is without contract or any type of guarantee assurance.

The trademarks that are used are without any consent, and the publication of the trademark is without permission or backing

by the trademark owner. All trademarks and brands within this book are for clarifying purposes only and are the owned by the owners themselves, not affiliated with this document.

Table Of Contents

Introduction
Chapter 1: Know Your Starting Point
Chapter 2: Ensuring You Have An Amazing Product
Chapter 3: The Portrait Party – Best Practices
Chapter 4: Marketing Your Party
Chapter 5: Advanced Marketing And Growing Your Business
Chapter 6: Checking The Numbers And Cutting Down On Costs
Conclusion

Introduction

I want to thank you and congratulate you for downloading *Photography Business: How to Make Money and Grow Your Business with Portrait Parties*.

This book contains proven steps and strategies on how to turn your hobby of photography into a sustainable income stream for you and your family. Photography has always been a hobby of mine but before standing behind the camera was my full time profession, I worked as an accountant. Through trial and error I converted my love for photography into a growing revenue stream, and a huge part of my success came through selling 'Portrait Parties'.

Whether you already make some income through photography, or if you are just starting out, this book will serve as the foundation for the tips and tools for how you can expand your business and increase your profitability. I have learned the most efficient way to spread word of my business, and to expand my clientele dramatically. I want to impart with you the knowledge that you need to lift your business off the ground.

To truly make it as a standalone photographer, you need to be more than just an expert behind the lens, you need the knowledge and business insight that comes through years

of experience. By the time you complete this book you will have all of the necessary information to make your photography business successful. From business plans to self-promotion, this book is your one stop guide to making photography a fruitful career.

Chapter 1: Know Your Starting Point

Equipment

Perhaps you are interested in photography as a hobby, or maybe you even run a small photography business already. Shooting portrait parties is a great way to expand your clientele and to convert your hobby into a full time profession. The demand is ever increasing and the practical usage of these shots is becoming more and more apparent to businesses and families. This is an effect of brick and mortar portrait shops falling in popularity and the rise of businesses having a need for a social media 'face.' Businesses love to have photos of their employees to post online and to give their stores a more personal feel. The need is there and you can certainly break into this business, but there are key pieces of equipment and knowledge that you will need to have to truly lift your business off the ground.

For starters, the equipment that you need to successfully build your business is more than just your camera. You will need photo albums to show your samples and frames to show what your finished product in the best possible light. You should be starting off with a fairly high end camera, think DSLR or something similar, but you will also need a portrait studio. This is a white background for shots, and even

if you specialize in outdoor photography, clients almost always want some photos in completely controlled lighting. The initial investment for this is not too much, at around $80-$100. You will also need to investment in a reasonable computer setup for processing your photos (we'll discuss monitor color calibration in the next section). This is all you need to get started, this and your artistic eye and love for photography.

I highly suggest against buying a professional printer for photographs, at least in the beginning. This is the single largest piece of equipment that you will have to purchase, but you should only do so after you have had a few photo shoots. I suggest only purchasing a professional printer with the money that you have made from your previous shoots. This gives you a target to work for and makes sure that you are not unrealistic about your aspirations. It is quite affirming to make a major purchase using funds from your hobby business. In the meantime then, you should contact local photo developers and discusses with them bulk rates or even a collaboration. Before digital photography was ubiquitous, I had a partnership with a developer in town. I referred customers to them when clients wanted more copies, and he referred clients to me when customers were looking for someone to do a photo shoot. This type of local collaboration, of free exposure of your work, will be essential in building your business. It helped me to such a degree that even if you already own a professional printer, you

may still want to reach out to your local print developers.

You Will Need To Have A Digital Camera

For true photography purists, 'digital' can often sound like a dirty word. The pragmatic approach to this business is that you absolutely will need to have a high quality digital camera. It's likely that you are starting with one, and if so great, move onto the next section, but if you are intent on sticking with 35mm photos I urge you to reconsider. I have seen photographers bank on their use of traditional photography equipment, but realistically this just isn't that large of a sell to clients. They would rather have the immediacy of knowing what the photos look like, and starting with a digital foundation makes it much easier to transfer and modify photographs. In addition to the benefits for the client, there is the hidden cost of film which can get expensive if you do lots of shoots.

If you are unsure of where to start with digital camera, I suggest looking at the Cannon Rebel series. Mid-tier cameras can be purchased for $200-$300 and the quality is quite phenomenal. The top-tier brand I would recommend is the Nikon D800 series. These cameras can cost near $3000 new, but used versions can be obtained for less than $1800. These cameras tend to be exceptionally well maintained because they

are so expensive and niche. Often the seller is just upgrading his or her camera and you are getting a fantastic product that is just one or two cycles out of date. The last camera I'd recommend is the Nikon D600 series. These can often be purchased for less than $500 used. It is still quite a hefty investment, but your camera is the essential tool that you will need to use all the time.

Software, Hardware, And The Knowledge To Power It

The first step of making a great photo is taking a great photo, but that is hardly where the process ends. You will need to manipulate photos, change color balancing, add effects if clients require, etc. This requires advanced software like Adobe Photoshop. While I'm sure that you have heard of this program, and possibly even have understanding of how to use some its more advanced features, the real benefit comes in seeing true masters work their craft in taking great photos and making them beautiful ones. It is imperative that you spend some time online watching tutorials on explanations of Adobe's more advanced tools. This book serves the purpose of building your portrait party business and will not assist you in the fundamentals of Photoshop. Truth be told, the best tools for learning the software comes in free videos on YouTube. Look for the finished photographs, the original, and watch how the photographer manipulated the photo. To clarify, I am

not referring to changes to alter the setting of a photo or to change the action in the picture, I am talking about how grounded photos with proper color balancing and removed blemished are created. These are the types of photos that your clients will want – photographs of themselves at their very best.

One of the most under looked parts of editing photos comes in the monitor that you use, and the time that you spend deciding the color calibration. To give you an idea, we want the monitor to accurately reflect the colors that will be achieved when the photographs are professionally printed. This is an important step and it shocks me how often it is overlooked. To accurately adjust your color settings you will need to have a printout of a photo with a wide color spectrum, and know the limits of the monitor that you are using. If you are using a laptop, regardless of how high end the manufacturer claims the screen to be, you will still need a desktop monitor to get an accurate idea of how the colors will translate onto paper. I highly recommend using an IPS monitor and if you can, one that is also HDR ready. HDR (High Dynamic Range) technology is fairly new in monitors, but my upgrade last year has been near life changing. The increase in the range of colors, particularly blacks, makes it much easier to edit night time photos. My last suggestion is that if you are using a desktop computer, you may want to

invest in a video card. The onboard processor for most computers will do OK when looking at large ranges of color, but the power behind a video card is really useful, especially if you are using more advanced editing effects.

I want to stress that the equipment I recommend is not a necessity to start your business, and that the by far the most important component of building a healthy client base is you. Ultimately if you decide to continue with photography, and especially if you would like it to be your main income stream, these pieces of hardware should be upgrades that you eventually purchase. In order of priority you will want: high quality digital camera, foldable portrait studio, computer with Adobe Photoshop, an IPS color balanced monitor, and lastly a professional printer. The minimum set of tools to get started is really just the camera, portable portrait studio, and Adobe Photoshop.

Base Connections

The internet and you will be a major marketing tool that we will discuss later in chapters four and five, but to get off the ground you will need to have a decent base of people that you know in your town or city. Arguably it is most difficult for a photographer to lift his or her business up when they have moved to a new location. Run through your mind and

think about the contacts that you have made over the years. This includes family, friends, and businesses; each of these is vital to your success. The best method of marketing to your town or city is to do free photo shoots. In order of priority, you will want to focus on businesses first. Offering to do free portraits for their wall in the office can be great for inroads with a large client base. You are appealing to all of the workers for that business as well as suppliers for that business. Never neglect your friends and family, and always offer to do these projects for free or at least at cost. This is actually quite useful as it helps you determine the cost for print photographs and gives you an idea of how long a photo shoot will take. This is information that is better to be determined before you start charging customers.

Portfolio

A portfolio serves more than just as a collection of all of your work – it is also your primary tool for selling your services. The base connections that you make near your home will do wonders to expand your portfolio, and you will need to dramatically increase the number of portraits that exist in your collection. Many photographers feel compelled to include their favorite photos that are outside of the desired project they want to complete. This means I've seen lots of scenic pictures of nature or of city architecture, and then artists try and use

this as a case for why they should be hired for portrait parties. You must remember that to the client they only care about the single service of the portraits that you are selling. They will not be able to make the connection between the wonderful photos that you have taken and how that will translate to portraits. This is often too far of a stretch for most clients. Your portfolio then should be a collection of portraits that show a wide variety of settings, angels, and lighting. Focus on these key differences between portraits to show the variety of depth that you can bring to the lens. Also, when displaying your portfolio to potential clients, always be sure to ask the persons in your portfolio for permission to show them on your website, or even in person. If the photos are of close ones then you a simple discussion would suffice for permission. If you are displaying someone that is not in your immediate family, then you will want to have written confirmation. The cheapest and most effective way to do this is through email – it is the written word and is time stamped. It's doubtful that friends that gave verbal permission would try and claim rights to any photograph you use to promote yourself, but you want to cover all of your bases and a simple email is easy enough to satisfy this necessity.

My Starting Point

It would be in poor taste to describe how to grow your

portrait businesses if I did not first describe how I came to be a full time photographer. Photography has always been a hobby of mine, but when it came to college, like with many, I decided to major in a field of study that is more widely applicable to a long term career at an established company. This led me to pursue a career in accounting, one that I would participate in for nearly five years. The entire time I was working as an account, I never stopped reading articles about new cameras, and never stopping taking photos. My Nikon was a mainstay in my work bag, even though for most situations it was not applicable.

In early 2009, the small company that I was working for went under because of the financial crisis of 2008. As I was looking for new work, I had more time to dedicate to my hobby. I started to do side jobs for parties and friends, and even did a wedding or two. I was unaware of what I should be charging for my services and the costs of my prints were not always clear to me, leading to jobs that sometimes made me only break even. It was during this time that I decided to dedicate some effort to working out the logistics of professional photography, and how I could potentially do it full time. It's worth noting that later in 2009 I did start working as an accountant again, but the few months where I was doing more photography invigorated me to find a way to make photography be my profession. This is the basis for this

book, and how I came to realize that portrait parties are a needed service and is the best way to grow your photography business.

My portfolio quickly incorporated more portrait shots until I had a dedicated album that I would use as an advertisement to sell to clients. I came up with reasons for why clients would want these services, and sought to seek out those people. This led me to weddings, business engagements, and family events like baby showers. Having a number of portraits done in a short period of time led to a great increase in my profitability, and when I discovered that the best margins are often made on picture frames, I decided to research the best way to order frames and insert the photographs myself. This was the turning point – the point in which I was able to quit my full time job and become a dedicated photographer. By the time you have completed the subsequent chapters you will know exactly how to do what I have done – how to quit your day job and turn photography into your main income source. It has been one of the most rewarding experiences of my life and I know that it will be a great experience for you as well.

Chapter 2: Ensuring You Have An Amazing Product

Samples, Samples, Samples

As you are starting your portrait business, your reputation is going to come from your samples. A later chapter will discuss how to distribute samples and get maximum exposure, however before we get to that step you are going to need samples that are not just beautiful, but also easy to understand. You are being hired for your artistic eye, for your specialized knowledge in photography equipment, and for your editing skills where it comes to photos. To present this idea through individual photographs is not just difficult, it is near impossible – to do this successfully you will need an accompanying laymen explanation.

We all have specialized interests when it comes to the arts and yours is photography. Very often we get too wrapped up in our own interests that the terms and ways in which we describe the style and substantiveness of our work is lost on those that just want a 'picture'. You must accept this, but at the same time you have to be able to convey your style and what makes you unique – what makes your photos rock, and why clients will want your service. Creating a sample book of your

portraits is an absolutely necessity, but you also need to practice explaining why a photo is spectacular.

Often I will have clients looking through sample photos and stumble upon one that they really like. They will either stop the page to examine the photo more closely, or they will point out that this is the style that they would like for their picture. This is your time to shine by explaining exactly why they made a good choice. Avoid terms like perspective, depth of field, or any filters or coloring changes that you may have made to the photos. Instead, you want to focus on why they like that particular sample. My most popular sample book is by far my wedding demo. It is here where clients look at beautiful outdoor shots and I explain the benefits of using a drone for aerial shots, or talk about how I modify the photos for the best possible clarity and picture quality. They do not need to know the specifics about the model of drone, and they don't need to know about the normalizing color spectrum technique I use on bright outdoor photos. They just need to know why they like the picture, and this key explanation is part of your pitch for why they should hire you.

Have your sample photo book ready, and practice explaining the techniques that you use. Instead of mentioning 'perspective', talk about the height of the camera - a much simpler concept to understand. This is also an opportunity to

determine exactly what the client wants. By pointing out the samples that they like, you can mimic that style in the final product for that client. This means knowing the techniques that led to your beautiful samples. You need to be able to reproduce these results consistently to grow you business.

The Frames Are Almost As Important As The Photos

The old adage that 'packaging is everything' rings true in photography. Your portraits are beautiful, but you need a way to present them that gives an idea to clients for how they will display your work. Your sample book will show your technique and your level of expertise, but you should also prepare a separate set of samples of framed photos. I personally like to do this on the day of the shooting, provided the client has time. Take copies of the photos that the client enjoyed from the sample book and prepare some different style of frames for the photographs. A later chapter will discuss the best practices for getting the best deal on frames, but know that if you have not worked as a freelance photographer long, a lot of the margins are made on the frames themselves. You will want to have a good selection so a client will always immediately find something they like. You also want to curate the selection and tailor make them to the style and setting for their portrait party. Sometimes this can be as simple as displaying outdoor photos in wood frames and

indoor photos in white frames, but even this minor distinction is incredibly helpful in having a client decide on the final product.

You should also use this opportunity to go over with the client where they would like to display the photos. Since photography can be a very personal business, I've had clients walk me through their homes, indicating where they would like to display photos of their family. Use this as an opportunity to listen to the client and process their request as best you can. If they want a style of frame that you do not sell, try and accommodate them even if it cuts down on your margins. If the style of frame is something that you do not sell but keeps on getting asked for repeatedly, you will want to try and find a vendor that sells a similar frame.

It's important that you sell your photographs as they would be displayed. This is more for your own benefit than for the customers, as with the time investment and the equipment costs, you will need the picture frames to run a profitable business. If repeatedly clients decline to have photos framed, you will need to change your strategy to raise the importance of the framing. I would go as far as to only shown samples in frames – this is the level of importance in selling the frames to help your bottom line.

Go Above And Beyond

After you have taken your photos, there will be some days between the session and the delivery of the final product. You don't want your customer to forget about you, so a great tip is to give a digital version of the product right away. This means that on the evening of the shooting, email some samples (the best photos) to the client. This will have them keeping you in mind, and a simple delivery system can act as free marketing. I've had clients forward emails to family, friends, and coworkers – something they would have been much less likely to do had they not had immediate accesses to the photos, and in such a simple delivery form. This email is also a great time to express your gratitude for their business, and helps establish you as part of the community. The idea of community and building your place within your location is extremely important, and we will focus more on that in the later chapters specializing in marketing.

Another way to have your customers keep you in mind is to immediately give them a USB drive with some of the best photos that you've taken during that session. This is slightly more expensive, but with the cheap price of USB drives, the cost averages to about two to three dollars per drive. For my own business, I load the best pictures onto a USB drive and ask the client if they would like samples through email or USB. More often than not clients want the USB drive because it is easily available. You can use this as an additional opportunity

for free marketing by ordering custom USB drives with your name on the outside.

Do not use a USB drive or email to have a client decide between styles and coloring. Some clients will have the knowledgebase to ask you for specific styles, or at least have some idea of what they want even if they don't know the proper terms - EG: "I'd like one of this in that washed out tone" – referring to Sepia. However, most of the time clients that do not have specific requests want you to make those types of decisions. This is good – they are trusting your judgment in presentation and is the very reason for why they are hiring you.

Learn To Say No

A common trouble spot for those starting a photography business, let alone a more intensive portrait businesses, is doing estimates on the spot. A common technique that businesses use is to settle the price of the total portrait party on the spot. While you will have guidelines for general pricing, each and every party will be different, and this is especially true for businesses. Do not feel pressured on the spot to accept a price, and instead tell the client that you will have to get back to them at a later time. This almost never leads to a loss of business and is important because you do not

want to lose money on any one of your projects. You will want to reply to the client quickly with an accurate estimate for how much the portrait party will cost, but never feel that you need to give a number right then and there if you are unsure of the underpinning costs.

Never Stop Learning, Never Stop Expanding

Portrait parties helped grow my photography business to the point that it is now my full time job, but this never would have happened had I stopped learning new techniques and technologies. A rising part of my business has been through aerial photography, in addition to portraits. This has proven to be extremely popular at weddings, and growing in popularity among businesses. The technology behind aerial photography is quite difficult to learn, and I had to spend many unpaid hours learning how to properly fly a drone (truly difficult when trying to take stable photos), but the end results absolutely justify the time and money investments.

This is perhaps even truer for your technique and style. As portrait parties become more popular, your competition is coming up with unique ways to sell their products and to take photos. Keep your competition in mind, whether geography close or across the world. You can learn a lot about what is becoming popular among clients in other regions, and use that

technique to bring more business to yourself. For example, in recent years I have done more seasonal photos than in the past. The way in which I was able to increase these sales was through the looking at how my competitors were selling the same product. It turned out that customers want digital editing, particular in 'fun' or seasonal shots. It was something that I had not tried to sell any clients on as I thought they would not be interested, but looking at competitors gave me the motivation to try and sell clients on the idea. Lo and behold that clients were excited about the idea, and it spurred new photo shoots with customers that I had previously serviced.

Depending on the density of your area, you may need to expand far outside of your local town. I live in a suburban area, and over the years my radius for doing photo shoots has increased year over year. If you feel that driving two or three hours for a shoot is not worth it, that might very well be the case, but know that it is very common to have to travel quite a distance to get more clients. This is particularly true with weddings, as they can be in remote spots outside of heavy population centers. Be prepared to modify your business plan to accommodate for clients that live far away from your home. You will need pricing for the gas and transportation, and you will want to do this accurately – there is nothing more disheartening than losing money on a shoot by miscalculating

the price of transportation, or miss assigning the value of your time driving to a location and back.

Chapter 3: The Portrait Party – Best Practices

The Basics

The purpose of a portrait party, for you the photographer, is to get all of your subjects in one spot and to increase your revenue through lots of shots in a small amount of time. Portrait parties are held by families for weddings, baby showers, engagements, reunions, and all other common affairs. Businesses utilize portrait parties by taking a great looking photo of each and every one of their employees. Businesses do this to promote themselves online, to make identification cards for workers, or to decorate their offices. A portrait party typically lasts between twenty minutes to an hour, although it could be as long as four or five hours. Portrait parties typically include between five and fifteen subjects.

You will need to have a client outline exactly what they want for their portrait party and you will fulfill that demand. It is important to sell them on a particular theme for cohesiveness to the portraits. The primary money maker for you is the pictures and frames that you sell to those at the portrait party, in addition to the set prints that they receive

and the initial time that it takes to shoot the photos.

The demand for portrait parties has always been around – it just used to be served by large retail stores' photo departments and by small photo shops. Nowadays, the standard is to hire an individual photographer that can give a much more custom experience, and often the price is less for the consumer because of the lowered overhead costs. The cost of your services will vary greatly on your experience and the equipment that you are serving the party with. For example, aerial drone shots are significantly more expensive because of the inherit cost of the equipment, as are heavily edited shots that require time editing on a computer. As you start your foray into portraits, one of the most important aspects is pricing your framed photos appropriately as this will be your main revenue stream.

Selling The Idea

The term 'Portrait Party' has risen to prominence recently, but I still do not find this to be the best way to sell clients on the idea. The best way to market to clients is to advertise directly to their needs, and it is not enough to say that a nice photograph is worth the cost – you have to instill the idea that the photograph is valued because the subject and event are valued.

When selling to families, you have to hit the key points that matters most. This means captivating the client with the idea of preserving the memory of an event, and clarifying the importance of why they might want a professional photographer. This should be the beginning of your sales pitch before you show any work to customers. This sales pitch is important to make even when the client absolutely wants your services – it gives you the leverage to charge the appropriate rate and to impart the importance of your services. This is important to expanding your business, as early on the greatest promotion tools are past clients. It also helps greatly when selling more expensive prints after the shooting is complete. Laying this groundwork is dire as many people view photographs as a commodity, as something that is interchange between one photographer and the next. By expressing your interest and the importance of the shoot, you are letting the customer know that your portrait party is more than a commodity – it is a service that they can only receive from *you*.

For businesses, the key to selling yourself is the practicality for the portrait party. You will have to describe the use cases for the photographs and what you are able to bring to the scene. You will have to describe what you can do that others can't – this means keying in on your ability to edit the

photos past shoot, the professionalism that you bring to the table, and the one stop shop for servicing their portrait needs. Even if you are going to an outside vendor to print the photos, you want to show the business that they *only* need you and that you will satisfy every need they have. Often times, this is the most important aspects of a business buying prints – they have a need for the product and they want the full service experience. While a family might look through your portfolio and describe exactly what they want, a business is far more likely to look at samples and ask that you simply mimic one style. Play into this and use it as a selling tool for your services and appease them by providing the service and not asking too many questions to clarify what they want. They just want photographs that serve that businesses particular interest. This clear cut business approach is a great way to spread your name through the business community. Business owners spread word about photographers that get the job done with minimal fuss – that is your goal and that is the photographer that you want to be.

The Key Is In Confidence

Your sample photographs, the equipment you provide, and your technical expertise all pale in comparison to the selling tool that is *you*. There is arguably no hurdle more difficult than overcoming the stigma that photography can be

done by just about anyone. To overcome this imbedded idea, you have to be sure about your own abilities and the service that you provide. The questions you ask about preferences and the guidance you give to subjects posing are key aspects in exhibiting the professionalism that you must exude.

The only person that knows how a photograph is going to turn out is you, and you are also the only one that can fix lighting and posture of a subject. At some point during your portrait party, you must tell subjects how to pose themselves for the best possible shot. You have to do this even if the photos would have already come out great. It is small moments like these, adjusting the details of the frame, that tell the client that you are worth the money. I know that this sounds a bit cynical, but you *are* worth the money and this is one way of conveying that idea. You are doing other work behind the scenes to make a great product and being forceful about placement is merely the most overt way to convey this idea.

Demonstrating your confidence outwardly through the way you stand behind the lens will translate into better photos for every type of portrait party, but it becomes doubly as important for children's events like mitzvahs, confirmations, or birthday parties. This confidence can be exhibited by the smooth transitions you take to adjusting the light fixture for a

photo to the type of directions that you give. It is around the twelve to thirteen years of age threshold that this confidence will be the most important. For younger children, they truthfully will hardly acknowledge that you are there. For kids of this younger age group it is simply best to communicate with the parents to facilitate the best photos that you can shoot.

Selling The Material Goods

You've already read that a good portion of your margins will come from selling your framed photos. It is your job to position these framed photos as a good that is of desire to families and of necessity to businesses. Truth be told, many families will want framed photos after looking at your samples – it is the businesses that typically will opt for digital or simple prints only. To make your case to businesses you have to mention the practicality of having nicely framed print photos of all of the employees. Your case can be made in three parts: one, a business that displays its employees towards the customer oriented side of the business is more friendly. Two, the frames you sell can be reused for other photo shoots that you conduct in the future. And three, the photos and frames double as a decoration and a boost to morale for the office or business. These are three difficult points to convey because while the ideas ring true, you want to sell these ideas in a

serious tone that is not inflated or too self serious. Businesses will need to see your services as tools that can use to improve productivity or increase their customer base.

The case for presenting framed photos of the staff, or even just a single large framed shot of the entire staff, is that businesses that take this approach seem friendlier to customers. I have found that the best way to pitch this idea is to describe the business in question as a family, and that customers feel more comfortable in a household as opposed to a store. You can broach this topic by describing popular trends of other businesses, and you can do this even if you haven't framed photos for any other enterprises in your town. Be careful not to push this idea or any other idea too hard, instead rely on the business owners' desire to compete and be modern. The idea is simple enough to sell from a bottom line point of view because of the increased desire for personal service with the advent of customer relations being more important than ever with social media. From personal experience, it is the smaller, more local shops that will be intrigued through this sales pitch.

The idea of reusing your picture frames with shoots that you will take at a later time can seem a little daunting to sell, but making the case is as easy as showing the business sense in continuing your partnership. Mention the heavily discounted

rates of reframing the photos and that you understand they are a living breathing entity, and you know that employees will come and go. You will always be a phone call away and can do another shoot for new employees. If the business decides to frame the photos themselves and they need to redo shoots than this would actually be more expensive than buying your frames the first time and paying a nominal fee to have you reframe. Selling the idea in dollars and cents has been the most successful way to approaching this type of sale.

 Lastly, the easiest pitch is for decoration and for office morale. I like to start this pitch by talking about the common meeting areas in the office, the water cooler for example. Mention that the photos work well as a decoration and that you know having employees framed helps build morale and a sense of unity. You might be questioning these ideas, but this sales pitch comes from the actual use case of many of photographs by actual businesses. This is an idea that I heard several times before I started to invoke it as a selling tool. Unity in an office can be made by exposing coworkers that don't see each other in day to day operations through hanged photos in common meeting areas. On numerous occasions I have had business clients, large and small, tell me that new hires are more enthusiastic about joining a business that treats and displays its staff as family.

Growing Specialties

As you expand your business through portrait parties, you will want to consider expanding your specialties, or focusing on a single specialty for your geographic region. You will want to make this decision based on the other photographers in your area and what they specialize in. Some specialties to consider are indoor shots, outdoor shots, or aerial drone shots. Each one of these specializations requires both technological knowledge and equipment.

The easiest specialty comes from indoor shots. All you need is your already present eye for photography, and staging equipment for lighting. The staging equipment is the backdrop and high intensity light used for portraits. This specialty opens the door for identification card photography and school yearbook photos. This specialty is easy to get into and the equipment will run a total of $200, even for the fanciest back wall for indoor portraits. You will want to have made connections for printing these photos or have a professional printer yourself – this is often the most challenging part of making the margins work in your favor.

Outdoor specialization requires extensive knowledge of Photoshop. You don't necessarily need to be a wiz to get started, but it certainly will help. You should never discount

the difficulty in making the lighting work to your favor. I have found that for most outdoor portrait parties there is a heavy amount of editing that needs to be done for the photographs to come out in the best possible quality. You likely have many outdoor shots of nature or buildings; to illustrate the point of the importance of altering these photos in post production, take one of your existing photos and take a subsection of that picture. This means to look at the larger picture and take one quarter of the photo. If you now compare quarter this to a different quarter of the photo, you will see the inconsistencies in lighting, even among the exact same surface. There are a myriad of factors that cause this phenomena, and in scenic shots it does not impact the quality of the shot. The problem is that with portraits this hidden effect leads to 'weirdly' lit portraits. It is especially a problem with portraits where the subject is fully standing. Get some time with Photoshop under your belt so you can fix these problems and get your outdoor shots rolling.

The last specialty, and truly the most lucrative currently, is aerial drone shots. There is an extreme cost and skill requirement before you can do this type of photography, but the benefits are so major that you should at least consider this specialty after you have some portrait parties under your belt. These types of shots are used by many different businesses, and families often desire aerial shots of large

events like reunions and weddings. It has become the number one way to differentiate yourself from other photographers; however you will need somewhere between twenty to one hundred hours of practice before you can start charging for these shots. They are extremely tricky to take due to variables in the drone you buy, the lens you equip on the drone, and especially the wind in which you trying to take photos. To start you will need a suitable drone – I started with a $500 drone that did not have particularly good stabilization, and while you can do shots with a drone in this price range, you are risking a lot of the quality of your photographs on the weather. Better drones for photography will cost you about $2000, a hefty sum no doubt, but at this price range you are getting stabilization technology that makes taking these photos infinitely easier. I would certainly start with regular portrait parties before offering drone services, simply because of the prohibitive cost.

Taking photos once the drone is in the air is actually quite simplified from where it was just a few years ago. You will mount your camera onto the drone and using software, tether your phone to a separate cheaper camera included in the drone. Your phone will act as the primary camera that you will use to frame shots, while the actual higher quality camera is mounted above the imbedded camera included with the drone.

One of the more troublesome spots for this type of photography is that you are essentially strapping a $2000 camera onto what could be a $2000 drone. The uniqueness of drones has led to a lot of surprising problems that I never thought could arise. While shooting a wedding in the middle of the country, I had a few kids with BB guns try and shoot the drone out of the sky. I had to stop taking shots until I could locate the shooters. It would have been a major financial calamity if $4000 worth of equipment was lost because of some rebellious teenagers. There was also a time where I got complaints from neighbors at a party I was shooting because they were worried I was spying on them. These types of complaints have seldom happened, but they seem like they will be on the rise as the number of drones in the sky continues to increase.

These are just some things to keep in mind if you decide to get into aerial photography, but the most important aspect is learning how to pilot the drone and take the best possible shots. You will want to experiment in different types of weather, and it takes dozens of hours to just get the general feel of the drone. The mounted camera that gives you a view from your phone is useful, but the actual piloting requires both that viewpoint and your viewpoint from the ground. I don't have a shorthand for how to learn how to photograph using a

drone quickly – all I can say is practice and photograph subjects in a wide array of lighting and wind conditions. Once you feel comfortable, advertising this feature of your portrait business will be quite lucrative.

Chapter 4: Marketing Your Party

Business Cards

The first order of business for advertising is to get business card drawn up for yourself. A box of several thousand can be purchased for as low as $200. You will want to spend some time on creating a tasteful business card that details your business and the services that you offer, as well as the address for your website where you will list additional information and pricing. This is absolutely the first step in marketing your business. Before you do your first portrait party, have business cards drawn up. You will want to be careful with how you hand these cards outs, meaning you don't want to force them upon people. What I typically do is keep several in my wallet in case someone at a portrait party asks for my business card, but I also take twenty to thirty cards and put them on a table near where I am taking portraits. At the end of the party, I take all of the cards that were not picked up, which is usually most of them.

You Will Need A Website

Every business, large and small, requires a website to be successful and to get the most amount of exposure. For photographers, your website is of extreme importance and can

really hinder or help your business, depending on how well conceived the website is. Customers view photographers as artists, and this extends to the way that they view promotional material. If you are already a programmer or have someone that can help you launch a website, you may still want to consider using a more expensive site builder. The formatting of the website and the clarity in which customers need to be able to find information is just that important.

There are several businesses that specialize in website creation, but out of all of them I would recommend Square Space. You have likely heard of this company before as they have risen to prominence as larger companies like Go Daddy have fallen out of favor. Square Space offers a great assortment of tools to build your website and they will also cover the hosting of the website. Even if you have never built a website before, or know very little about the backend of hosting, the services offered here are impeccable for the beginning user.

There are three pieces of information that you need to have on your website. First, you will first need samples of your photographs. As mentioned earlier, your portraits will be of customers and you will need their signed permission to use their photos online. You can avoid a lot of this hassle by getting a verbal agreement from family members. Second, you will need information about how long a portrait party takes

and how much your services are. For more information on pricing, refer to chapter six. The last piece of information you need is the additional costs and services that you offer. This is where you would list how much framing photos costs, special events like weddings, and the cost of specialty shots like using a drone. Again, for pricing and making sure that you have a sustainable business, refer to chapter six.

Doing Facebook Right

Facebook can be used both the right and wrong way, and more often than not I have seen photographers starting their portrait business using it in a way that drives away interest. Your Facebook page for your business should include a limited amount of sample photos, and it should not be used for making statements or comments to promote your business. The best way to utilize Facebook is as a place for customer feedback. You will want comments from satisfied customers, and to increase your positive comments, mention to satisfied clients that a good comment will really help your business. Other than feedback, information about pricing and specialties should be listed on your dedicated website. Use Facebook just as a redirecting tool to your website and keep the Facebook page as clean and as simplistic as possible.

The common error that I see among many

photographers is too much self-promotion on Facebook. This means posting comments to other accounts and trying to spread yourself around the internet. This will only hurt you as it increases the odds that you attract the wrong type of attention. Small businesses like ours do not have dedicated staff to monitor their social media, and I've seen trolls completely decimate existing pages because the photographer was too aggressive in their advertising. Think of Facebook as merely a checkbox that you need to tick when starting your business, not as the major play for advertising.

Know The Competition And Where You Can Stand Out

The benefit of getting into portrait parties is that you are specializing in a particular avenue of photography. Take a survey of the competition in your area before you draw up business cards and before you work on the pricing listed on your website. If you notice that your competition focuses on outdoor photos, do not try and offer the same service to simply match the existing competition. You want to differentiate yourself from existing photographers through slightly better pricing and increased specialization. I have seen photographers try and expand their repertoire too quickly to match the competing photographers in their area. This benefits neither you nor your rival, and you will both suffer by

heavily advertising the same services. Focus on your own skills and goals and just be aware of what the competition is doing. It's helpful because they have already tested the market in your area and you can get a good idea of what acceptable pricing looks like and the types of services that are desired in your area.

Chapter 5: Advanced Marketing And Growing Your Business

Support Local Businesses And They Will Support You

Whether it's set pieces, backdrops, software, tripods, or any other pieces of equipment that you need for you business, you will want to buy these locally when you can. Local stores do a lot for small businesses that operate out of the home and they are the ones that are most willing to allow you to lightly advertise on their premises. I mentioned in an earlier chapter that print shops are a great inroad for free advertising. Getting to know the workers and managers will lead to them recommending your services when customers come in and ask about having portraits done. This actually happens quite often, and brings up an important aspect of advertising for portrait parties – most customers will seek the service before they ever see one of your advertisements. You simply want to be the path of least resistance to getting the portrait party done.

The more local business owners that know about you, use your services, or know that you support their business, the more clout you will build up in your town or city. Currently, I have my business cards available at the checkout register at eight businesses in my town. This has driven a lot of the

demand that I get from local customers. To get businesses to give you this type of support, I urge you to offer your services at heavily discounted rates, possibly even a loss. The bridges you build through your local shops will help you for many years afterwards.

Support Local Charities And Events

One of the greatest advantages that you have is that your services can only be purchased locally. The only ones that can take advantage of your photography need to be within driving distance or willing to pay for your transportation. You must use this to your advantage and the best way to do this is by supporting local charities and events. The organizations that you want to connect with are churches, local leadership groups, and the schools and sports teams in your area. You will need to do a lot of unpaid work in your town to build strong connections, but these connections are so important that I implore you research the common meeting grounds in your local neighborhoods.

To start, churches are ubiquitous and attract a large following in most major towns and cities across America. You do not need to be religious to head to your local places of worship and present yourself as a photographer that can help at events and regular meetings. Typically places of worship

have someone that takes photos, but this is usually a volunteer using something akin to an iPhone. These photos are not the best quality and you will be able to offer a far better product. It's important that you position your services as free and that you are doing it for the exposure. You want to reassure ministers and religious leaders that you don't want to do very heavy advertising, and that you just want to be able to display some of your business cards at a heavily trafficked location, like the refreshment's table. Usually the largest point of concern is that your services are free and they feel as though you are going to try and cheat them with obnoxious advertising. You have to put these fears to rest while making clear that you think your presence will be enough to drive interest to your business. Religious leaders in particular are cautious about free services, and so you may want to offer absolutely no advertising whatsoever, and that you will only keep business cards in your wallet in case someone asks you about your services. This usually puts to rest any concern about using your skills and will get your feet through the door.

Other common meeting spots like the Boy Scouts of America and the Veterans for Foreign Wars are available throughout all of the country. These organizations are typically well funded but simply do not allocate any money in the budget for photography. I have found that for these types of events you do not need to offer your services for free, and that

you can charge a small sum, typically one third or a quarter of your typical fee. Make clear that the discount is in exchange for some free exposure and that like with religious organizations, you merely wish to place your business cards near a heavily trafficked area like tables carrying food. Some of the best events to participate in are Eagle Scout ceremonies and pot luck dinners. These events draw far more people from the community than the organizations normally do and they will multiply the amount of exposure you get. It's also worth noting that you can offer framed photos to these groups, particularly the Boy Scouts. Typically the Boy Scouts want framed photos of their Eagle Scouts and you will be able to offer this service for cheaper than other framers. It also gets the word out that you offer that specific service, and again, framing will be your main source of income in the long run.

Lastly, get involved in public schools, particularly when it comes to sporting events and group clubs. I have done photos for football teams, including portraits for entire teams, chess clubs, and more. The huge benefit here is that there is a likely customer that wants to buy your high quality prints – the parents of the students. This is great because it allows you to not only sell the photos, but also the frames. The most challenging part is informing the parents that their children have had their portraits taken at school, as very often students will neglect to tell their parents (even though parents will have

signed off on allowing photos of their children to get taken). The best way to get started is to offer the organization your photographing services for free, and just inform the head coach or head club members that you'd like them to tell parents that they can buy prints or framed photos. All you will need to do is supply a number of your business cards to these groups and they will hand them out to parents. As a bonus, coaches and school leaders change out their teams and add never members every single year. Do a good job and you are essentially guaranteeing yourself repeat business for many years. I started doing portraits for the high school football team around six years ago and have had the pleasure to return every single year since I started. This has opened up an incredible number of doors among local families.

There is one challenge that comes from dealing with schools and that is the bureaucratic mess that consumes local school districts. You absolutely need to make sure you go through the right channels; otherwise you risk never being able to do business with any school. This means that you cannot approach a coach or group leader first – you must get in contact with the principal, or even in some cases, the district superintendent. This minor bureaucratic inconvenience is well worth the hassle because of the amount of business it will generate. To give you an idea though, the whole process of approaching a school district and being able

to work with them can take upwards of three to four months. This is just a matter of getting permission from the parents coupled with the slow nature of non-academic school communication. I currently work with four school districts, and I have found that it gets easier with time. Districts do not operate in an absolute vacuum and informing one district that you have worked in a neighboring town can reduce the time it takes to get your foot in the door. For your first school district, the best time to approach administrators is one to two months before school ends. This ensures that all staff is still present and usually aligns with a lull in how much work needs to be done. Typically at this point most paperwork has been settled for the following academic year and they can give more attention to your request.

Chapter 6: Checking The Numbers And Cutting Down On Costs

You Will Need A Viable Business Strategy

I hope your goal is to eventually turn photography into your main source of income. To do this, you need to think about yourself as a business. The first order then is to create a viable business plan, including pricing for your services and products.

I don't want to tell you how much to price your portrait party or your time, as there are a lot of variables like how much of a hobby this is for you, and the distance you are from a client. I will say that my starting price was $60 for a thirty minute portrait party. This fee covered taking photos and the usage of my equipment, as well as digital versions of all of the photographs taken. Your connections to a print shop, or if you have a professional printer, will be a large determinate in what you charge for different prints and at different sizes. Early on and before I had a professional printer, the pricing was largely established by the rates that my local print shop could offer me. If you are outsourcing your printing, you will want to approach whoever is your print supplier and state that you will have many prints coming through. If you can make a clear case for the volume that you plan on having going through their

store this will lead to a much cheaper price for the prints. Do not be dismayed if they do not offer you a great rate right away. You may have to deal with one or two months of inflated prices before a shop gives you greater discounts. Also, while you do not want to burn any bridges with any businesses, you will want to check out other print shops and see if they can undercut your current expenses.

Eventually you will need to buy a professional printer. To best make use out of this major investment, and to determine when you should make such a purchase, calculate what the current cost is per photo in all of the common sizes. You can then determine what the cost would be from a professional printer – sometimes this information is hard to find, but you can always call the manufacturer to get a pretty decent idea. This is a type of phone call that they get all of the time, as long term printing costs separates them from their competition. Make this expensive purchase only when you have calculated your current margins and what they would change to after such an investment. I hesitate to say to buy such a machine right away because depending on the print shop, they may offer extremely competitive rates that make worrying about maintenance on an expensive printer not worth the difference in margins.

Know What The Competition Charges And Where To

Buy Your Frames

The biggest aid in pricing your product appropriately will come from the existing prices of your competition. You will need to make sure that your competition treats their photography business as their full time job to get an accurate idea of how they price their services. You do not need to undercut your competition, but rather use their pricing for a guide to know how much to charge for framing and printed photos. This information will give you key information on if they are doing their own printing or if they have partnered with a local print shop. When it comes to the prices that they charge for framing, or if they even offer frames, you will want to charge a similar price but get your supply from the cheapest possible market.

To get the best quality frames at the best price, I suggest forming a partnership with either a local supplier, or buying large orders of several different frames from China. Truthfully if you want to make photography your main source of income, you will have to buy frames from overseas. A great way to do this is through Alibaba.com – this is the equivalent to the world's largest Walmart. You will be able to get great margins on your frames, but you will also have to buy a sizeable number of them to get a purchase to go through. You should also be aware that the shipping times for these products can be

up to three or four months, so you will want to make a decision and then prepare for the gap in delivery. My business would not be able to exist as comfortably as it does if it were not for Alibaba, so I cannot recommend them enough.

Conclusion

Thank you again for downloading *Photography Business: How to Make Money and Grow Your Business with Portrait Parties.*

I hope that you feel comfortable with the prospect of starting your photography business, or that if you've already started; you have the tips and essential knowledge to grow your business through portrait parties. You now know how to build connections in your community, make the margins on your photos work in your favor, and how to specialize in particular photographs to increase demand. Most importantly, you understand the importance of expanding your business with portrait parties.

The next step is to create your business cards, make a website, and to start advertising to local shops and organizations. There is an exponential curve to small businesses like ours – you will need to lay down the groundwork before you can reap the benefits of increased customers and demand. Make those connections now and use the selling tips as described in chapter three. Photography has been your hobby all your life – now it's time to make it your full time job as well. There will be hurdles along the way, and it's important that you be realistic about the time it will take to

grow, but hard work and networking will lead to successes as portraits and photographers is a demand that needs to be met.

Finally, if you enjoyed this book, it would be greatly appreciated if you could leave a review on Amazon. It is through readers like you that this book will increase in popularity and help others expand their photography business.

Thank you and good luck!

Photography Business

A Beginner's Guide to Making Money in the Music Business as a Photographer

T. Whitmore

Table of Contents

Introduction
Chapter 1: This Industry is No Walk in the Park
Chapter 2: The Importance of an Internet Presence
Chapter 3: How to Adequately Capture Photos at a Live Show
Chapter 4: How to Take Promotional Photos
Chapter 5: Tips on Shooting Profitable Album Covers
Chapter 6: You're the Director – How to Shoot a Music Video
Chapter 7: All About Electronic Press Kits
Conclusion

© Copyright 2016 by T. Whitmore - All rights reserved.

The follow eBook is reproduced below with the goal of providing information that is as accurate and reliable as possible. Regardless, purchasing this eBook can be seen as consent to the fact that both the publisher and the author of this book are in no way experts on the topics discussed within and that any recommendations or suggestions that are made herein are for entertainment purposes only. Professionals should be consulted as needed prior to undertaking any of the action endorsed herein.

This declaration is deemed fair and valid by both the American Bar Association and the Committee of Publishers Association and is legally binding throughout the United States.

Furthermore, the transmission, duplication or reproduction of any of the following work including specific information will be considered an illegal act irrespective of if it is done electronically or in print. This extends to creating a secondary or tertiary copy of the work or a recorded copy and is only allowed with express written consent from the Publisher. All additional right reserved.

The information in the following pages is broadly considered to be a truthful and accurate account of facts and as such any inattention, use or misuse of the information in question by the reader will render any resulting actions solely under their purview. There are no scenarios in which the publisher or the original author of this work can be in any fashion deemed liable for any hardship or damages that may befall them after undertaking information described herein.

Additionally, the information in the following pages is intended only for informational purposes and should thus be thought of as universal. As befitting its nature, it is presented without assurance regarding its prolonged validity or interim quality. Trademarks that are mentioned are done without written consent and can in no way be considered an endorsement from the trademark holder.

Introduction

Congratulations on downloading *Photography Business: A Beginner's Guide to Making Money in the Music Business as a Photographer* and thank you for doing so.

The following chapters will discuss how you can grow yourself a prosperous and flourishing business as a photographer in the music industry. While this field is certainly competitive, there's no reason why you can't set yourself apart from other freelancers who exist in the industry. There's no doubt that after reading this book, you'll feel more confident in your ability to go into the world of music photography and win jobs that you may previously have been unable to obtain. One reason why the music industry is unique is because your attitude is arguably as important as the work that you produce. This book will also discuss the 'tude that you need in order to instantly win over your clientele.

There are plenty of books on this subject on the market, thanks again for choosing this one! Every effort was made to ensure it is full of as much useful information as possible, please enjoy!

Chapter 1: This Industry is No Walk in the Park

The music industry as a whole largely depicts a lifestyle that is glamourous, fun and cool. Due to these factors, it's often assumed that anyone who is in contact with band members, producers, or other auxiliary music industry staff must conduct themselves in a similar and effortlessly cool manner. For an aspiring music photographer, this could certainly make this aspect of the business nerve-racking. You might feel like you have to carry yourself in a certain way in order to "make it" in this type of photography niche, but this is simply not the case. While these considerations can cause any fresh photographer to feel inadequate or lame, the reality is that a photographer's work ethic and production quality will always far surpass his or her outer persona. Just like in any other industry, hard work will yield you larger profit. Developing a reputation for quality work will often save you from being deemed uncool within the music industry community. This is a good tip to remember as you become more acquainted with the idea that you are definitely going to pursue a career in this industry. Now that this myth has been relatively debunked, the rest of this chapter will focus on how you can best target the long hours of work that you put in towards

optimizing your business endeavors. These tips will help you to see that cool clothes and a nonchalant persona are far less important than delivering quality photographs that will keep your customers coming back again and again.

The Profit of Working for Free

It's not a surprise that most people cringe at the word *internship*. If you've already graduated college and need to pay bills, working for free can seem like a complete impossibility. However, if you're committed to opening up new doors for yourself within the music industry as a photographer, an unpaid internship might be one of the best places to start. Not only will an internship help you to gain experience that would not have been possible without one, it's also likely that you'll meet industry experts who can provide you with recommendations and job leads when the time comes for you to find a job that pays. It's an unfortunate yet realistic reality that many companies that exist within the music photography industry will often only look to hire people who have some form of experience or knowledge base of the business as a whole. Of course, if you're hoping to start your own business, it might be more beneficial to simply take photos on your own time and add them to your portfolio, but this type of effort will most likely begin as a free service as well. Working for little to money can be tiresome because you might have to get a part time job to make ends meet; however, it can be rewarding in the long run and is generally a humbling

experience for most new music photographers.

Understand a Photographer's Pay Cycle

Whether you're fully against the idea of an internship or you're considering how to make this type of employment work for you, it's important to understand how much you can anticipate being paid as a music photographer. It's safe to say that one of the reasons that you're following your passion to become a photographer is because it's something that you care about. While it may seem great to be able to get paid to do what you love, it's important to know how much you're going to get paid within this industry. One of the benefits to working for a company, such as a music magazine or a niche business, is that it's likely that you'll be paid hourly or on salary. On the other hand, if you choose to work for a business that already exists, it's likely that you'll have to work full time, possibly doing a variety of tasks that are unrelated to taking photos on a daily basis. While having a full-time job can provide stability to your life, running a business that is truly your own will provide you with a sense of independence and excitement that can far surpass simply working for someone else. Here we will look at a cost breakdown of each type of niche photograph you can offer to your clientele:

Average salary while working for a company	Between $45,000 to $49,000 per year

Average salary working freelance	Between $100 to $250 per shot or per event, depending on what you negotiate
Average salary when working an event	Between $0.00 to $2,000 per event
Average salary when shooting a music video for someone	Between $100 to $500 per video
Average salary when creating an electronic press kit	Between $50 to $125 per hour

As you begin to think about how to price your services, it's important to remember that many companies already have rates in place for these types of services, and they may be lower or higher than what you'd generally used to. Due to the competitive nature of the music photography business, it's also ill-advised to charge astronomically high rates for your services if you're freelancing because it's likely that many people who are looking for services will ignore you as ridiculous. Just like any economic market, you should price your services within reason and in a way that corresponds with the supply and demand of the industry in which you're working. Simply looking at the financial side of this industry proves that you're going to work hard to make a career out of this type of business if you're serious about it.

Quality is Quality

Arguably more important the internship that you find or how you conduct yourself amongst others in the music industry is that fact that quality is quality. The music business is competitive, and if you're unable to prove that your work can contend with the best, you'll be quickly tossed aside and replaced with someone who can deliver the level of work that is required. While internships are certainly important in the sense that they can help take your career to the next level, your primary focus should be the skill level of your personal photography. Deliver lousy results and you run the risk of obtaining lousy jobs, regardless of any other factors about your personality or networking contacts. While the subsequent chapters will shed significant light on how you can best achieve high quality photos, you should be constantly pushing yourself to deliver the best to your clients. It's hard work, but your reputation is on the line. In this way, it's worth it to pay attention to detail and edit your photos like a champ.

Understanding a Photographer's Lifestyle

Even if you do end up working a company rather than as a freelancer, the hours that a music photographer works can be long and overwhelming for some people. Generally, a music photographer can expect to work between five to six nights per week, and in addition to working mostly nights, you have to spend your days editing photos, corresponding with new and potential clients, and keeping a good social

media presence. All of these factors can lead to an overall sense of fatigue in a short period of time. It's important to understand that this type of work can be extremely draining, especially if your workload is (hopefully) growing at a quick pace. It's important to properly estimate the time that you'll be spending working on your career, so that you can prioritize other areas of your life accordingly. Many dream chasers have ended up achieving their goals, only realizing that they had to sacrifice family, friends, and experiences when it was too late to do anything about it.

Push Yourself, but Be Yourself

One last tip that's important before you embark on any type of career that involves music and photography is the need the importance of leaving your comfort zone. If you don't push yourself to act in new ways, how will you ever make mistakes, learn from these mistakes, and figure out the best ways to make it in this industry? Mistakes help you to grow. This being said, it's also important to keep your own unique personality intact as you begin corresponding with big wigs and celebrities that are beyond prevalent in the music industry. No one likes to work with someone who is arrogant or who is standoff-ish. You'll need to make sure that your approach towards the people you meet are engaging, professional, and fun. At the end of the day, it's important to

remember that you're working with music, not figuring out financial numbers or attending important business meetings.

Along these same lines, it's important to not get caught up on the mantra that you're guaranteed to fail or that taking professional photographers for musicians is a waste of time. While advice from others can be a helpful place to start when you're considering your career options, there should be a point where you stop listening to any negative talk or doubt that people are trying to convince you of. Of course, it might be safer for you to get a job in an industry that guarantees employment, but where's the fun in that? Explore yourself and your capabilities as a photographer, and it's likely you'll find numerous ways to grow your skillset.

Chapter 2: The Importance of an Internet Presence

Never before in technological history has it been easier to create a brand for yourself on the internet. For an aspiring photographer in any field, this is a great opportunity for you to display your work in an atmosphere where harsh criticism is the norm. Of course, the more you put yourself out there, the potential exists for criticism to be harsher, but this will also allow you to grow. Similar to the saying, "all publicity is good publicity", the same can be said about an aspiring photographer. The more exposure that your business gets, the easier it will be for you to book jobs and keep recurring clients. This chapter will provide you with tips on which social media platforms to use and how you should be using them.

Facebook

Besides MySpace and AIM chat, Facebook was one of the social media platform with which internet users were first initiated. Facebook connects all people, and this is why you should be using it to promote your photography if you're not already. This doesn't mean simply posting your professional photos on your page for your friends to like; rather, there are

specific ways that you can target all Facebook users in a way that will promote your business to all people, not just your friends. Let's take a look at some of the ways that you should be using Facebook. While you might already have some of these tactics in place, chances are that you're not using all of them.

Facebook Tip 1: Create a Page

If you want to gain real traction on Facebook, you should consider creating your own photography page. While posting your photos on your timeline can be fun because your friends can see the work that you're doing, the reality is that they're the only ones who can access what you're producing. Creating a page and making it public will let anyone see your photographs. They'll be able to share your page, and their friends will see that they're liking a public page. This will entice more people to also check out what you have to offer. If you don't have a page yet, you should look into creating one. They're super easy to make and will give your photography presence on Facebook a more professional feel.

Facebook Tip 2: Wisely Choose When to Upload Your Content

Once you have a page going that looks professional and pleasing to the eye, you want to really consider when you're going to upload your photos and other types of content to Facebook. Facebook in particular, in opposition to other types of social media platforms, is rich with bored people who are looking for the next most interesting thing to read about and or look at. This being the case, you want to first make sure that the content that you're uploading is intriguing to the eye. It's important that your photographs and content are engaging. Before you post, you should think to yourself, "what does this post offer to my audience?" More so than with other types of social media outlets, discount codes for first time subscribers to your content and links to band websites are great ways to keep your audience coming back to what's new on your site. Make sure that your potential client base is excited to see which new bands you're capturing with your camera. Additionally, it's important to not bog your followers' feeds down with content. You should only be posting once a day, probably late in the day when people are bored, ready to leave work, and are scrolling Facebook for interesting stuff to look at.

Facebook Tip 3: Consider Facebook Advertising

Another relatively new option for Facebook users who are interested in promoting their business through marketing is Facebook advertising. This approach is extremely simply to implement and doesn't even cost much money to get started. Simply go to the ad creation tab when you're logged into Facebook and select from the drop-down menu what type of advertising you're interested in. For example, you can choose the "Clicks to Website" option, which will allow you to copy and paste your photography's website URL into the advertisement. This will manifest itself in users being able to click on the advertisement and be directed to your website. This type of advertising costs only between twenty-five to fifty dollars per month, depending on the payment option that you choose. This type of advertising doesn't simply go to your personal friends or close family; instead it will reach a radius within an address point that you predetermine online. This way, your advertisement is reaching the largest number of people possible within your relative area.

Instagram

Another type of social media platform that has certainly helped more than just the excited selfie-taker to get noticed is Instagram. Also owned by Facebook, Instagram is arguably a better tool to document a photographer's work online. While there are no "pages" on Instagram, it is possible for you to

create multiple accounts, and this is recommended for anyone who is a professional and looking to expand their reach beyond people that they know.

Instagram Tip 1: Make Your Account Public

I know that it may sound absurd, but I have definitely seen aspiring photographers on Instagram who keep their accounts private. Why? I have no idea. If you want to get the largest number of people looking at your work, you need to make your account public. One of the most critical reasons why you need to make your account public is because of the search page on Instagram. Instagram's search page is customized for you. It not only shows you celebrity pages that you might like, but it also helps you to engage with other users based on the posts that you've "liked" in the past. This goes both ways. If you have users that are following your page who are "liking" your photos online, you page will show up on their friends' search feeds as pages that Instagram thinks they should start following. This is essentially free advertising. Failure to keep your Instagram account public drastically reduces that reach that your Instagram page will have.

Instagram Tip 2: Link Your Posts to Your Bands' Instagram

Instagram makes it possible for you to reach all of the fans of the band with whom you're working. Again, this can be considered free advertising. By using the principles of Twitter, a simple #hashtag in the description of your post that depicts the band's name or the venue that they're performing at will automatically upload to that specific forum within the Instagram community. Of course, you might want to do some hashtag research before you post to make sure that it's a hashtag that is currently being used by the band, but that shouldn't be hard to figure out. Another great tactic is to describe the photo with the band's Instagram name in it. For example, if your current gig has you taking photos of the Red-Hot Chili Peppers, then your post would include @chilipeppers in it, because that is the Red-Hot Chili Peppers official Instagram account. This is a great way to promote your photography for free, because it's likely that if you post a phenomenal photo of the band, their fans will start following you and will be more likely to purchase goods in the future that you're posting on your Instagram, especially if you're offering discounts in conjunction with these goods. Who doesn't love a deal?

Instagram Tip 3: Find Bands Who Will Promote You

The last time for using Instagram most effectively is to form relationships with bands in a way that they will promote your work for you. This tip primarily has to do with the quality of the photos that you're cranking out for your customer. For example, if you are shooting album covers for a band and you also have a good relationship with them, they might be more apt to give you a plug in the description of the photo of their album cover. Their post might read something along the lines of, "New album dropping next week. Make sure to get your copy! Special thanks to the genius photographer @insertyouraccountname for making us look like the rock stars that we are". A simple post like this will entice their audience to look at the rest of your photos. Additionally, if you are able to form strong relationships with the bands for which you're working, they'll be more likely to recommend you to other artists that they know, which can only grow your career in the future.

Start a Blog and a Website

Any type of photography business is distinct and special when compared to other types of business ventures because a photography marketplace can primarily be online. To say it a different way, as the owner of a photography business, you don't need a storefront in order to be successful. Additionally, your website or blog can serve as your resume or portfolio instead of any formal piece of paper. If you don't currently

have a website for your photography business, I strongly suggest that you create one as soon as possible. You're missing out on the opportunity to generate more traffic to view your photographs, which is the equivalent of missing out on an opportunity to make money. This is probably more important than having a presence on Facebook or a presence on Instagram, even though Instagram is a perfect forum for any aspiring photographer. Get your content on a website, and start the process today if you haven't already done so.

 Similar to a website, fresh entrepreneurs often overlook the importance of cultivating a blog online. If you're a relatively decent writer in addition to being a good photographer, this shouldn't be difficult. **Www.wordpress.com** is a great tool that can help you to get started blogging. The only downside to this type of website is that they keep their website's name in your domain name. For example, if you were to work with Wordpress, your domain name would read **www.photographyonline.wordpress.com** instead of simply **www.photographyonline.com**. You may not care about this minor detail, but some people do because they think that the extra .wordpress makes their website appear unprofessional. The choice of website application is yours. Blogging can certainly help to keep your fan base engaged. Especially in the music photography business, who wouldn't want to read about the interactions that you as a photographer

have with band members, and how your experience as a photographer influences your daily life?

 While only a few types of social media platforms were presented in this chapter, it's important to recognize that any and all social media presence can help to grow a business. Other potential outlets that you might find helpful include Snapchat, Twitter, LinkedIn, and Pinterest. Snapchat in particular might be most helpful to a music photographer, because it would be easy for you to snap some photos of yourself and the bands with which you're interacting while you're at concert venues or photoshoots. People get excited to see others working with band celebrities or at cool places, so don't be shy to show off some of the perks of the job. Also, remember that your social media presence for your photography business should be separate from your personal account, unless you're making the conscious choice to create a brand that has you at its center. Curate your social media in a way that is unique, fun, and engaging. It will pay off in great ways in the long run.

Chapter 3: How to Adequately Capture Pictures at a Live Show

Now that you are aware of the importance of the hard work that's involved in becoming a music photographer and how social media can help to optimize the hard work that you're putting in, it's time to turn our attention to focus on specific ways that you can make money in the music photography business. While you're welcome to try out any of the techniques that are presented throughout the rest of the book, it's important to understand that you will likely be most successful if you stick to one niche within the broad umbrella that is music photography. For example, instead of offering a large variety of services to your clients, you might become known as the "guy who makes the best music videos" or "the lady with the best live concert pics". A good general rule is to start out by experimenting with photography in multiple ways, and then choose an option that will be most rewarding for you because you have confidence that you're successful at it. This chapter will focus on tips to make your life at a live concert photographer easier. While this field is extremely competitive, there's no reason why you can't shine through the mediocrity and create a fulfilling career for yourself.

Step 1 to Becoming a Live Show Photographer: Start Small

It's safe to say that most great performers and entertainers got to their ultimate goal of mass stardom by starting small. As a music photographer, you should think about following this lead. It's ill-advised for you to walk into a large venue and start trying to immediately compete with other photographers who have had years of experience while you have none. It's likely that if you're looking to start taking photos for musicians professionally that you might already have a friend or two who's in a band. You should ask him or her if you can shoot them at a concert for free. It's unlikely that they'll say no. Additionally, these types of venues often don't require you to have specific press badges if you want to bring your camera along with you to the show. Due to this fact, it's the perfect way to experiment with your photography skills.

Step 2 to Becoming a Live Show Photographer: Invest in a Fast Lens Now!

Once you've picked a venue that you know will not be filled with experienced and competitive photographers milling about, you should consider purchasing a fast lens prior to the concert date. In order to understand what a fast lens does, it's important to understand what aperture is. While it's safe to assume that you know what aperture is because you are interested in photography, for those of you who aren't aware, aperture refers to a hole or an opening through which light passes. In the case of a camera, a lens'

aperture refers to the size of the opening at the front of the camera. Generally speaking, the smaller the aperture number (or *f number)*, the larger the light source and camera viewing hole. While starting at a small venue can be a great way to gain experience, one of the key problems with starting at a small venue is that the lighting is usually terrible. Because the overall space is smaller, the lighting is usually limited to only highlighting the performer and is less worried about showing off the stage or decoration behind it. While this might be good for setting an intimate ambiance for the audience, this is unfortunate for the budding music photographer. It's likely that in this type of space, your photos are going to come out looking like the performer you're shooting has just come back from Mars and is looking to start a singing career.

 A fast lens will allow more light to pass through the lens of the camera. The "fast" aspect of this type of lens refers to the shutter speed of the lens, and a faster speed will also help you to obtain more light for your photograph. As a beginner, it's generally recommended that you use a cheap 50mm 1.8 lens because this type of lens allows you to capture photos in situations where the light source is almost nonexistent. Another great tip to eliminate any tonal problems that exist from colored lights being used is to make the photo black and white during the editing process. This will take the shot from looking like it was taken on another planet and make it look normal again. Purchasing a cheap but effective fast lens will save you loads of time in terms of frustration and feeling like your pictures at small venues never turn out quite right.

Step 3 to Becoming a Live Show Photographer: Turn Those ISO Settings Way Up High

ISO refers to the sensitivity of the sensor on your camera that detects an image. The higher the sensitivity settings, the more sensitive your camera is to light. This means that the higher the ISO setting, the greater ability your camera has to see an image through the darkness that exists around it. This being the case, you should be using a high ISO setting in conjunction with a low f number setting on your camera so that you can optimize your photo for lighting in a dimly lit small venue arena. High ISO settings will allow you to capture musicians without the use of a flash, and this might be necessary when working in a "no flash" concert arena. While ISO is an important concept to understand for any photographer, it's important to realize that the higher your ISO setting, the grainier your photo is going to appear. The grain that you see with a high ISO setting is known in the photography world as "noise". In order to reduce this noise, it's recommended that you purchase noise reduction software for post-production editing after you have taken your shots. This will make your pictures stand out from others that look grainy and frankly like an amateur took them.

Step 4 to Becoming a Live Show Photographer: Moving onto the Larger Venues

While some people might find comfort in the idea of starting their music photography career at a small venue, others might find it more preferable to just jump into the competition that exists at a larger venue. Contrastingly, maybe instead you've been working at smaller venues for quite some time, and you're ready to move onto bigger and better things. Of course, this book definitely promotes the idea that you should first gain experience at smaller venues before moving onto larger ones, but regardless of the reason why you've made this decision, there is one consistency that exists in the world of a larger venue. This consistency is that you'll most likely need a press pass in order to shoot at the venue.

Don't panic! Either through having an internship or through building up your portfolio and having a good online presence to prove that your credentials as a decent photographer exist, the first step to this process involves being represented by a larger company. Generally speaking, this means representing a magazine, a radio station, a website, etc. Of course, you can try to represent yourself as a freelancer to get a press pass, but this is difficult. Can you imagine if every venue allowed freelance companies to shoot photos and video at their events? There's a chance that there'd be more press than fans if that were the case. When you contact these media outlets to see if they are in need of a photographer for a given show, it's advisable for you to send them a link to your *website* instead of your Facebook or Instagram. A website looks more professional than other social media applications.

If you are unable to find a media outlet that will sponsor you, try not to become discouraged. Instead, start contacting other people within the industry who you know have contacts at venues. You might have to be a bit craftier, but the chances are that the more people you contact, the more likely you are to find someone who will provide you with an in. Remember, don't be afraid to leave your comfort zone in order to get what you want. And don't be disheartened by the disappointing word "no". If after these tactics you still can't find anyone who wants you to take pictures at a certain event, it might be time to go back to your work itself and see what needs improving. When you're asking around for a pass, try to contact the artist's manager first, and the venue's PR person second. The manager has more power than the venue, typically.

Chapter 4: How to take Promotional Photos

Maybe the idea of standing around hundreds of sweaty people in hopes of getting some decent shots of a band isn't for you. Or maybe it is for you, and you've developed a relationship with a band who trusts your work and they are looking for you to be their consistent photographer. This chapter will focus on how to take promotional photographs of bands. While the key to any type of photo is certainly knowing what type of equipment you should be using and how much lighting and exposure is necessary for the given conditions in which you find yourself, these types of considerations are only a small part of the larger equation of a promotional photograph. Promotional photography is most successful when the photographer has done the necessary preparation beforehand. This being the case, knowing what type of preparations need to be made is particularly important to you as the photographer.

Preparation 1: Know Your Band Before the Shoot

You should make a point to meet the band and listen to their music prior to the promotional photoshoot. Every band has a different vibe, and it would be a big mistake to misinterpret their attitude. Notice their style and the style of their fans, and try to take photos of them at this event so that they have an idea of your style as well. While this meeting should be about learning the style of the

band, it should also be about taking note of their physical characteristics. For example, consider jotting down the height of each band member, because this will help you to figure out how they should be placed within the future photo that you're going to be taking.

Preparation 2: Find Your Location

Location scouting, while it sounds fun at first, can actually be extremely time consuming. If you're getting paid a flat rate to take these promotional photographs for the band, it's unlikely that you're going to want to cut into your profit margin by spending significant amounts of time on finding the perfect spot to shoot. To avoid this tedious task, it's a good idea to first ask the band if they have any locational ideas in mind for the shoot. If they have a relatively good grasp on what they want their photos to portray, they should be able to direct you towards a spot that speaks to their overall style and brand. If they are proving to be indecisive, you can also ask your friends and family for ideas to save yourself time. Another possibility is to look at search engine results for places that other photographers have used as photoshoot spots in your general area in the past. Of course, you don't want to copy anyone or be redundant, but it's likely that you'll find new and refreshing ways to capture these spaces than did photographers who came before you. Additionally, your lens aperture levels and ISO levels will be determined by how much light exists in the location of your

photoshoot. If you're shooting in areas where there's a lot of light for your subjects, it's likely that you won't need the fast lens that you would need for taking live concert photos.

After you have found your location, it's a good idea to take some photos at this location during the time of day that the photoshoot is going to happen. When you do this, you should experiment with as many different light sources as possible, and take photos from as many angles as you can. After you are finished taking these photos, you should study these light sources in order to figure out how you are going to set up your lighting on the day of the shoot. If you don't do this beforehand, you run the risk of looking unprofessional or sloppy. It's more than likely that an aspiring band will be watching your every move carefully, especially if they are a band that's low on funds and are investing in promotional photos in hopes of gaining popularity. Taking precautions to make sure that angles and lighting look good before the photoshoot begins will make you look better and will make the band that you're shooting more comfortable. The photos will reveal the band's insecurity if they're feeling nervous or unsure of you, the photographer.

Preparation 3: Think About Band Member Positioning

Once you've found a location, met the band, have seen their height differences, and understand who are the leaders of the band, the next step is to think about composition. Composition refers to the placement of objects in a photograph or in other forms of art. A

key aspect of composition involves finding a balance between all of the bodies and other forms that exist within the photo, and having all of the parts of the photograph force the eyes towards the goal or message of the art piece. Think about it. Have you ever seen a band standing in a straight line for a photoshoot? Band placement is extremely important when shooting a promotional photograph, and there are many considerations that the photographer has to make in order to get this type of placement right the first time.

 Additionally, another technique that many photographers use is positioning the band that they're photographing in a triangular way. Let me explain. If you position the band so that you can trace triangles between each of the member's heads, you'll come to find that your pictures are balanced and in equilibrium. To accomplish a sense of depth while still keeping with the triangular formation, try placing the band members in a way so that members that are the same height are situated at opposite ends of the photograph.

 In addition to composition, anything relevant concept to think about as you set the band members up for placement within a photograph is the idea of perspective. Perspective makes it possible for shorter people to appear taller and taller people to appear to be the same height as the shorter members of the band. For example, if you were to lower your perspective so that your camera is on the ground and the band members are slightly above you, you can put the shorter people in the back and the taller people in front of the shorter people. This will give the illusion that the shorter people are the same height as the taller people, without the need for step stools

or tall shoes.

While the idea of triangular positioning may seem overly simplified, there are some music photographers who use this type of positioning for every single one of the professional photoshoots. The principles of composition, balance, and perspective are three key concepts that should be considered as you move towards shooting promotional photographs. Lastly, it's important to remember that often it's the confidence of the photographer and the planning that he or she has done before the actual shoot that truly captures a great photograph. People, especially artists and musicians, can tell when someone feels unsure about their craft. Take your time, be deliberate, and you're already halfway towards finding success.

Chapter 5: Tips on Shooting Profitable Album Covers

While many factors between shooting a promotional photoshoot and shooting an album cover are similar, there are key differences that need to be discussed. This chapter will highlight the subtleties that exist when shooting an album cover for a band. Unlike a photoshoot, an album cover is usually more important to the band as a whole, because they have been working on their songs for quite some time and they probably want their album cover to reflect the hard work that they've put into their songs. The photos that you take for an album cover need to reflect the overall message that the band is trying to convey through a particular album, rather than simply speak to a style or genre of their art. Let's take a look at how you can best accomplish this type of photography.

What's Your Vision?

The previous chapter stated the importance of getting to know the band that you're shooting prior to the day of the photoshoot, and when shooting an album cover the need to meet the band before the day of shooting is arguably even more important. Not only do you want to know the style of the band that you're shooting, you also want to know the story that's behind the songs that comprise the entire album. In this way, you might want to ask

the band if you can listen to some of the songs on their album before the day of shooting. Another good tip is to research some of the promotional photos that the particular band in question has produced in the past, so that you can have a clear picture of their general style. After you've done your research, the next step is to brainstorm small story lines that can exist within the album's cover that complement both the style of the band and their album's message. Next, pitch your ideas to the band members to make sure that they're on board. Nothing is worse than getting to the day of the shoot and capturing your photos, only to have the band tell you that there is no congruency between their vision and yours.

Pick Your Location

It would be redundant to go into how to properly pick a location for an album cover (if you missed the previous conversation regarding this topic, head back to chapter 2), but it's important to keep in mind that the location should be within budget for the album cover. Work within your means so that you don't end up losing money on the job.

Remember to Be Square

If you're new to shooting album covers, it's easy to overlook the fact that these photographs need to be in a square format. Your

photographs simply won't turn out if well if they are formatted as rectangles and then you later try to convert them to square. While Instagram has popularized the idea of the square photograph, it's obviously also inadvisable for you to use your smartphone to capture an album cover for a band. Instead, let's take a moment to recognize some of the key qualities of a square photograph, so that you can better understand how to optimize these factors for an album cover.

- **Balance:** In the previous chapter we discussed finding compositional balance through techniques such as the triangular method. When dealing with square photographs, it's important to recognize that the purpose of the photograph is not to move the eye towards a central focus point or from side-to-side through the art of positioning; rather balance here is reflected in the symmetry that exists on all four sides of the photo. The frame is symmetrical, and so that figures within the frame must also reflect the principles of symmetry.
- **Space:** In a rectangular photograph, it's often considered bad for the composition of the photo as a whole if there is a ton of negative space in the frame; however, in a square photograph, the composition can often be improved upon by getting closer to the subject and including a lot of negative space around the figure. While this tactic may not be beneficial for a band that has many members in it because it will be more difficult to include all of these

members in the frame if there is a lot of negative space, it should be considered if you're shooting a single musician or a two-person band.

- **Simplicity:** Due to the fact that the square framing option offers less space than a rectangular shape, simplicity is seen as preferable. Often, it's more difficult for a photographer to create artistic simplicity than he or she may think at first. Think about this way – you want your photographs to be as impactful as possible, so that the band feels like their album's message is being transmitted through the cover as a starting point. If there are other images within the small square frame that are distracting your viewers, it will most likely take away from the message that you're trying to send.
- **Central Composition:** The triangular composition that is a good technique to use for promotional photographs is not considered to be a useful technique for squarely-framed photos. Instead of thinking about each head of each band member being triangularly positioned from one another, it's a better idea to find equal composition on both the right and left side of the photograph. The middle of the photograph should contain balance, so that the eyes are able to move outward from that central point.

Positioning the Band

One aspect of positioning the band that we did not mention in the promotional photographing section is the idea of a lead man or woman. If it's agreed upon that the leader or key member of the group will be in the front for all of the photographs, you have the relatively easy job of having the leader pose in front of the other band member. If contention exists in terms of who is going to take the front-and-center position in the photo, you have a few options. The first one is to ignore the disgruntled feelings of some of the members within the group and take the photos based on your understanding of the dynamics of the group. The second option is to work with the group so that everyone is given equal exposure. While doing this might be the most comfortable option, it's important to understand that this might compromise the band's marketing strategy or popularity. The third option is to speak with their manager (if they have one) and figure out how you should position the band. Be adaptive, and listen to what the band has to say. You don't want to get caught in the middle of a messy internal band feud.

Camera Specifications

For both promotional photographs and for album cover photographs, a decent camera to use for these types of shots would be one that offers a full frame, a megapixel image sensor, and includes an image processor. The lens should also offer a wide variety of shutter speed options, considering you can't always be

sure of the location in which you'll be shooting or the amount of lighting that you'll have. You'll also want to invest in a flashgun of some kind, preferably one that will allow you to provide light in discrete and unique ways. For example, if you are taking a photograph where the lighting is dim and you need to get more light to the artist's faces, but you don't want to directly flood their faces with light, you can use the flash gun to direct the light to ricochet off of a wall and onto their faces. This will create a softer, more natural look.

While the primary focus of this chapter has been regarding how to shoot album covers when the album cover will feature the members of the band, it is also likely that there will be times when you're asked to create album covers where the primary focus of the photo is not the band but rather an object or a shape. If you find yourself in this position, understand that the same rules apply for both people and objects that you're shooting within a square frame. Remember, a key factor to any square photo is the illusion of balance.

Chapter 6: You're the Director – How to Shoot a Music Video

While photographs are a great way for a band to gain recognition, sometimes it's necessary to go further. That's where the idea of shooting a music video can come in handy. This chapter will focus on a situation where the band with whom you're interacting desires more in terms of publicity and stardom. It will include a discussion on topics such as what equipment you'll need, the types of people you'll need to recruit to help you record the video, and how you can optimize the editing process. The first broad steps to this process include talking to the band that wants a video shot, and making sure that they have a song in mind that they'd like to promote through the means of a video. Then, you will need to talk to them about what type of platform they'd like to use after the video is complete. Will this video be uploaded to YouTube? Will it be used on their website? Are they planning to use this video as a demo so that producers and other types of people can see their talent? This type of information will help you to figure out the budget that this project will entail, as well as how much you should charge this customer. Now that the basics have been established, let's take a look at specific aspects of shooting a music video that you'll need to think about

Don't Go It Alone

In the other types of photography that we've discussed

previously, it's been possible for you to primarily do the work on your own. When you shoot a music video, you'll need to gather a team of people who can adequately use the tools that are required while in production. Let's take a look at what some of these tools are:

>**Tool 1: A Camera Person:** Obviously, you are going to need a camera man or woman who knows how to shoot a decent music video in order to be successful at this task.

>**Tool 2: A Light Person:** If you're shooting indoors, you'll need to find someone who knows a thing or two about lighting composition and who can change the lighting settings of the atmosphere in which you're shooting.

>**Tool 3: A Director:** You'll need to find someone who can ensure that everything is running smoothly, and who has an idea of how the band or musician wants to look and be perceived through the contents of the video.

In a perfect world, you would be able to find all of these people who specialize in the respective fields above at a low cost and more importantly who can provide their own equipment. If it does turn out that you have to purchase all of the video equipment yourself, you should make sure that creating music videos for people is something that you will be consistently doing for a long period of

time. This way, you can budget the price of the equipment into the accounting system that you use for your business (if you use own), and keep track of the entire profit that you're making over time with these costs having been generated. Another option, if you don't feel like dealing with the high cost of video equipment is to rent your equipment. Regardless of how you obtain your equipment, you should be considering a team who can provide you support.

Design the Shoot

It's pretty obvious that you can't simply go from obtaining the recording equipment to shooting a random video. Creating a music video is a process that involves collaboration between the artist or band and the director. Similar to the process involved when deciding on how to shoot an album cover, shooting a music video will most likely require an even more intensive brainstorming session. Especially if you're planning on renting your video equipment, planning ahead of time will save you money if you are paying for the equipment on an hourly basis. If you're not paying the people who are helping you, they will certainly appreciate quickening the process. Let's take a look at the type of planning that will help you to quickly and efficiently shoot your video:

1. **Storyboards:** A storyboard is a sequential plan that documents how each scene of your video will look. Templates exist online that make it easier for new

videographers to document their storyboards in an organized manner.

2. **Lists:** After you have the storyboard completed, you'll want to list the crew members, the actors and actresses, and the props that you'll need for each shot. It's not necessary to document the band members unless you think this will help to keep everything organized. Everyone working on the project should already know who the stars of the music video will be.

3. **Briefing:** You should brief everyone on how the music video is going to progress once you have your lists and your storyboards figured out. You want good communication to exist between your project members, and you want to make sure that any and all questions that exist about lighting, camera angles, and other inquiries are all smoothed over prior to shooting.

After you have brainstormed and solidified your plan, it's time to start shooting your video. With all of the separate parts that we've already discussed working together, you should be able to create a video that's fresh, fun, and hopefully cheap to produce. As you shoot the video, a good rule of thumb is to try and get as much

footage as you can. Make sure that you have plenty of time to shoot, and that you document each shot that you're taking. This will make editing much easier. Keep the camera rolling as much as you can. While many of your shots will be planned, some of the best shots can come from unplanned occurrences throughout the big day. Once you have captured each scene as it was designed on your storyboard, the next step is the daunting process of editing your footage.

Editing

The truth of the matter is that even if you think that you have captured fantastic footage, only the editing process can take the footage and translate it into an equally fantastic video. Crummy editing results in unwatchable videos. Don't let this happen to you. In order to successfully edit your music video, you'll need to have primarily one person calling the editing shots. If you have multiple people all trying to make decisions, you'll never get anything done. Editing takes a long time, and you need to have patience during this process. As an editor, you have a few decisions that you'll have to make in regards to the video quality, such as how will each scene transition from the one before it, and how quickly will you move from one scene to the next? Consistency in a music video is important, because it tends to make the entire production move more smoothly.

Video editing software is pretty much essential these days if you want to be taken seriously as a videographer. Some free

software that comes with the purchase of a computer include Apple's iMovie and Adobe's Premiere Elements. A comprehensive list of software that you have to pay for but are considered the best in the business include:

- CyberLink PowerDirector 14 Deluxe
- Pinnacle Studio
- AVS Video Editor
- Lightworks
- Windows Movie Maker

Chapter 7: All About Electronic Press Kits

An electronic press kit, commonly referred to as a EPK, is an electronic file that bands give to interested media outlets. It contains all of the relevant information that the press would want to know about the band, like noteworthy awards that the band has received and biographies about each member. The purpose of an EPK is to make it easier for the press to access all pertinent information about a band without having to do extensive research. Think about it. If every press outlet that was interested in a band only had access to their social media accounts, it would take a lot of time for the outlet to gather all of the information necessary to decide whether or not they want to promote a band or run a story on a particular group. EPKs, while many bands have the tendency to freak out at the thought of making one, are relatively easy to create. Even if it only generates a few new fans or opportunities, they're easy enough to make so it's generally said that every serious band should have one.

The Software Needed to Create an EPK for a Band

Because you'll likely be charging by the hour to create an EPK for a band, you will want to spend as little as possible

on software and other resources. This being the case, we will primarily discuss how you can create an EPK for free. The best software that exists for the creation of an EPK is called Open Office. You can also use Microsoft Office Software, such as Word. Basically, you need an application that can turn a document into a PDF file. This is why Notepad isn't an option.

Most people have already used Word in their lifetime to create a resume or write a paper for school. Realizing that an Electronic Press Kit can be created using a tool with which most of us are familiar can help to debunk the myth that this type of file is intimidating.

What Do You Include in a Press Kit?

Now that you're aware of the simple software requirements that you need to meet in order to create an electronic press kit, the next step is to understand what you need to include in this document. Unlike a resume, it's okay if an EPK is multiple pages long. While we will go into detail in this chapter about what you should include in an EPK when you're making one for a client, it most generally should include anything that a media outlet wants to know about. It's important to realize that each type of press that a band seeks out to view their EPK will be interested in seeing different

types of information about what the band has to offer. Again, similar to a resume, you want to make sure that the EPK you make is easily navigable, so that the press can skip sections of it if they're not interested in all of the aspects that it has to

offer. Additionally, it's important to make sure that the EPK is

extensive and tells a complete story about the band. Some press organizations that look at your EPK will want to write stories on the band using that as a reference point, while others will be looking random facts that can be used for interviews or in other types of promotional ways. With these two broad necessities that you must include in an EPK have

been largely explained, let's take a look at all of the parts of an

EPK that must be included as you write one up for a client.

Include in an EPK 1: Band Bio

Your band bio should include information on who the band is, such as the name of the band, where the band is originally from, their musical influences, and the genre with which they most closely associate. Another way to get the attention of the press is by including quotes in the bio that are from articles or reports that people in the music industry have already written about them in the past. You want to make this section look impressive for the band, because this is first part of the EPK that the press is going to see. Include where the

band's career is headed and also include background information on the band. It's important to keep this section engaging, and avoid the tendency to document literally all of the information on how the band was created. This will become boring for the reader.

Include in an EPK 2: Band Pics, Album Covers, and Promotional Videos

The next section of the EPK should include artwork and promotional goods that can help to market a band, not only in the press kit but also for the possibility that exists if the press were to use these promotional goods outright. Of course, it will be most helpful to you if don't have to create these types of items for the band, rather they can give them to you to insert into the EPK. The positive side to this is that if you do have to great these products, you can charge more money for them!

Include in an EPK 3: MP3 Files

The EPK should include downloadable MP3 files of the band's music, so that the press can listen to the band's songs and appreciate the subtleties that exist within each one. For some artists, attaching files in this way poses a problem because they are hesitant to give out their music files for free. Radio stations especially will be eager to listen to your songs

without the hassle of paying for them. You should consider creating a password-protected Dropbox file that you can give to these types of sources.

Include in an EPK 4: Press Releases and Quotes

Especially if the band has recently released an album, it's important to provide your EPK with a press release so that these press professionals can take the release and distribute it for the band. It can be difficult to write a press release, and you should advise against a band writing it itself if they are thinking about doing so. The press release needs to hook the person into the work. Additionally, you should include quotes from the band's best interviews, with links that can take the reader to these original articles.

Here is a list of additional details that you will need to have in an EPK:

1. Contact info
2. Lyrics
3. Band Question and Answer
4. Cover Letter
5. Description of how the band's music has been used beyond simple live shows and album recordings (ex. Commercials)
6. Videos

7. Any additional information that could help a media outlet write a story on your band

Conclusion

Thank for making it through to the end of *Photography Business: A Beginner's Guide to Making Money in the Music Business as a Photographer*, let's hope it was informative and able to provide you with all of the tools you need to achieve your goals, whatever these goals may be. With the techniques presented in this book as your guide, you'll be profiting from the photographs that you're taking within the music industry in no time. Remember, if there's one piece of advice to take from this book, it's that the prevalence of the internet has created an environment that is conducive for aspiring photographers all over the world. Do not underestimate the power of the internet to expand your client base and photographic endeavors.

The next step is to grow your internet presence and your reputation. Proof of work that exists from your previous jobs are great sources of reference for future prospects. Once you have established yourself on the internet and have a client base, your current clients will be more likely to recommend you to their friends within the industry. It can start as a slow process, but persevere and be deliberate in your intention. If you work hard, it's much more likely that you'll see success sooner rather than later.

Finally, if you found this book useful in anyway, a review on Amazon is always appreciated! Thank you and good luck!

PHOTOGRAPHY BUSINESS

A Beginner's Guide to Making Money
with
Real Estate Photography

T. Whitmore

Copyright © 2016 by T. Whitmore All Rights Reserved.
No part of this publication may be reproduced, distributed, or transmitted in any form or by any means, including photocopying, recording, or other electronic or mechanical methods, or by any information storage and retrieval system without the prior written permission of the publisher, except in the case of very brief quotations embodied in critical reviews and certain other noncommercial uses permitted by copyright law

Contents

BOOK DESCRIPTION
INTRODUCTION
CHAPTER 1 REAL ESTATE PHOTOGRAPHY TIPS
CHAPTER 2 BUILDING YOUR BUSINESS STRUCTURE
CHAPTER 3 STRATEGIZING YOUR BUSINESS LOCATION
CHAPTER 4 CHOOSING THE RIGHT KIND OF INDIVIDUAL TO BUILD YOUR WINNING TEAM
CHAPTER 5 TAKING REAL ESTATE PICTURES WITH DIGITAL PHOTOGRAPHY
CHAPTER 6 BASIC RAW PROCESSING
CONCLUSION

BOOK DESCRIPTION

Investing in the real estate market has become one of the most profitable and booming ways to make money across the world. What do you think is the very first thing that people notice while they look around to purchase a piece of property? The answer would be the pictures of the home in question. People respond better to visual stimulation. For that reason, good quality, and interesting photography count significantly. When you're a real estate photographer, you must take it seriously. The reason behind this is simply because your livelihood is dependent on it! When you're striving to sell real estate pictures to real estate agents, and the pictures aren't really worth the money the real estate agent pays, your energy will go to waste.

Taking a picture is a learning process and there are important steps that you need to learn and comprehend in order to ensure that your pictures turn out to be perfect each and every time. This guidebook is absolutely a great starting point for beginners to help you learn how to use a camera, take the great pictures, and venture into a real estate photography business and become a wealthy individual.

Each and every chapter will take you step by step, to ensure that you understand every basic aspect of becoming a successful real estate photographer.

It is very crucial to have the right knowledge and skills when it comes to the real estate photography business. This book is the perfect teacher for you, as it will make you familiar with this kind of business as well as training and polishing your picture taking skills. Not forgetting all those who are new to this kind of business, this is the unbiased and perfect guidebook for helping the beginner get started with first-time picture taking to starting your own real estate photography business.

INTRODUCTION

This book is written with a clear intention of enlightening anyone who has a passion for taking real estate photographs. Taking pictures of different houses is a fun activity to do. That's the art of photography and, if you're reading this, you have a passion for that art. Well, you have taken the first step towards making money doing what you love which is taking photos of beautiful property.

It is undeniable, that you can make a lot of money and a good living just by selling real estate photos over the internet or working with various real estate agents and property owners to sell your pictures.

You can start a real estate photography business with little cash and only the basic equipment needed to start it up. You can even start your business in the comforts of your own home. This can be possible by finding a small space in your house for your business that will serve as your "office" space.

With the introduction of digital cameras, you don't even need a dark room to develop the pictures you have taken. All you need is a personal computer with above average specifications and photo editing software such as Adobe Photoshop. However, if you are aspiring to grow your business to a higher level, you may need to have some necessities such as experts to help you with your legal

documents and other useful equipment.

If you would like to make your hobby a business, you should not only have your basic camera unit, but the additional accessories as well. Of course, you would want your pictures to stand out and be more appealing to potential clients. You would need different zoom lenses and camera filters to make your shots clear, sharp and even have some special effects. Starting with a few of accessories will do, and then just gradually increase them as your business progresses.

Make sure you are dedicated and serious. You won't be able to get enough clients to sustain yourself if you don't take your business seriously.

When starting off with your business, you will need to incorporate some real estate photography business legality. First, you need to have your business registered and have a name and logo to be able to operate legally. Once registered, you can issue receipts and file taxes for your business.

Before starting any project, it is wise to write a business plan. Having one will help you identify your goals for your business and keep focused with these goals. This way, you will know if the business that you have started is worth all of your time and effort.

With your business plan, you can also define the different strategies

that you can use to make your business more profitable. You can change the business plan from time to time as needed. Having a business plan will surely help your business increase earnings, as well as help you to find ways in financing your business.

Your business plan should include your business' objectives. This is important because it will help you stay focused on how you want your business to grow in the long run. It should also include a marketing plan, how you intend to advertise and market your services to get customers. Also, the price you intend to charge for your services should be included. You may want to change this as your business grows.

And it will go on and on until you realize that you are now having difficulty arranging your schedule because of so many appointments. Of course, doing some marketing and advertising techniques would help.

There are many ways to gain clients. Many people consider real estate photographs as a very important factor when it comes to looking for new homes.

Real estate photography is crucial when it comes to marketing houses, it helps home buyers to value different houses before purchasing one. Frequently, they will put together a list of homes that they like depending on the photos that they see. Then they'll

send that particular list to their real estate agent and consider only those houses. If you do not have the amazing photos for the house you are marketing, then the house won't be included in the list.

For a homeowner who wants to sell his/her house, they should definitely consider the help of real estate photographers. These pictures are going to be vital to staging your home. This suggests that you will want all the decor in the room to be fairly neutral so that it is attractive to the different people that are taking a look at it.

Real estate photography will aid in showing off all of the different assets that a house has to offer. The more photographs that are displayed to the prospective buyer the more they'll want to have a look at the property. It's important that all photographs be extremely flattering inside the house as well as outside the home.

If you want to take the pictures to make your yard look as large as possible, and during the daytime, it is possible with real estate photographs. Real estate photographs will ensure that the prospective buyer gets all the pictures of the house including the front and the back of the property in the most appealing way. This will provide a clear view for the client to see exactly what the land looks like all the way around the property.

A good real estate photographer will also include additional details and descriptions to make sure that all different attributes of the house

are incorporated to entice the buyer.

CHAPTER 1
REAL ESTATE PHOTOGRAPHY TIPS

1) Dedication and responsibility - Starting a real estate photography business may seem to be easy to start, but it should be taken seriously. For anyone who wants to make serious income, dedication is imperative. You should also be responsible for all of your actions. After all, wouldn't it be nice to earn a decent income from something you have a passion for?

2) Strengthen your fighting spirit - In addition, you should have a motivating and inspirational spirit to keep your business moving. To fail at something you love to do can hurt deep down in your core. But you must remember that just because your real estate photos don't sell at first, it doesn't mean your business will fail. Have patience and perseverance, and also ensure that you learn everything about the real estate photography business before you start selling your photos for income.

3) Put forth more effort - The difference between an individual who makes it in the real estate photography business and one who doesn't is effort and commitment. Put time and effort into your real estate photo business to ensure that you make it in this competitive market. Ask yourself, do you have what it takes to sell your real estate photos? If the answer is yes, then you must commit yourself if you

hope to make it. That's the most important aspect of earning income through a real estate photography business.

4) Invest your time in your craft – What you earn from your real estate pictures depends on how much time you invest in your craft. You must put in the required time and you must remain passionate about what you're doing because that passion, or lack of it, will come out in your pictures.

5) Depict your creativity - You can take a thousand pictures of a certain house and not even a single one of them will sell. You need to step out of your immediate surroundings, get out of your comfort zone, and you need to think outside the box. Carry your camera with you wherever you go and be on the lookout for a house image that just screams at you.

6) Equipment – This one is a must, if you're going to sell real estate photos, you're going to need a digital camera. But to increase your chances of making more sales, you might want to invest in a few other things as well. The camera is the number one tool to consider, so you must have a digital camera. There are many on the market these days and most of them produce excellent quality photographs. The prices are coming down on them all the time, so you should be able to get a decent one for an affordable price. Apart from a camera, you will need editing software. Have you considered that you may want to doctor your photos so that they come out absolutely perfect?

Do you know how to use that editing software to its fullest potential? Finally, do you even know how to take good photos? This is just some of the equipment and thoughts that you need to consider when venturing into this lucrative type of business.

7) Be ready to face negative feedback - You may find out that some of your clients will not be satisfied with what you offer to them. As a result, you may receive bad reviews which will tend to demoralize your spirit of hard work. One thing to keep in mind is that you can't please everybody. If you take a beautiful photograph and nobody likes it, don't let it get you down. Maybe that photo was not what they were looking for, or maybe they just needed something different.

You must be able to deal with challenges positively or else you'll never make it in the real estate photography business. If you don't make any sales at first, just keep pushing forward and give it time. You must have patience until your efforts begin to pay off.

Work day by day, little by little, and before you know it you'll have the skill that it takes to sell real estate pictures and you would have done it from pure knowledge and hard work. Let's now get down to business, I know you have made up your mind in venturing into real estate photography. This book will favor all sides, from a novice to becoming a pro in photo shooting. If you are new to the photography industry and you don't have any clue on how to begin your career,

this book is definitely your teacher. It will take you through all the basics of digital photography to setting up your own real estate photography business.

8) Capturing the best images - The objective is to sell the house, therefore, your photographs need to be positively appealing to the folks who see them. Attempt to highlight the top characteristics of the house; the attributes that future buyers may want to find matter the most. The photography additionally depends on the characteristics of the property - residential or commercial. Basically, the photographs really should display your talent and skill. While looking for real estate agents to view the images, sometimes you'll want to offer them samples, so capturing the very best images will greatly aid to clinch the deal.

9) Selling the images - To earn a living with real estate photography professionally, give yourself a couple years for developing a solid base of clients. You can put together a professional website with your portfolio, current projects (if any), specialization skills, and plenty of high-definition clear pictures for possible purchasers to view. Needless to say, you must undertake alot of marketing for getting the clients. Begin by searching the region you're located in and any others that you might have quick access to. Get in touch with the realtors inside the region, show them your sample images, and when good luck is on your side, you'll gain your first deal!

10) Acquiring high profile clients - Obtaining higher profile real estate agent customers who will probably purchase your photos will not be easy since there could be better professional photographers all around you. In addition, you are lacking practical experience in the beginning. Consequently, after working for a couple of years with local real estate agents, consider migrating towards getting higher profile customers. The pay rate is unquestionably higher but you should possess genuine ability and knowledge to get an edge over other individuals. Ask yourself - exactly what is there in you that sets you apart from other real estate photographers? After you answer this, build on that factor for superior projects.

Naturally, finding the higher profile clients will not be very easy. Be ready for sample photo shoots as a part of a personal sales pitch.

CHAPTER 2
BUILDING YOUR BUSINESS STRUCTURE

For a successful real estate photography business, you will need to do a lot of work when setting it up. We are going to address some important issues that will help you build a map of success.

1) A NAME THAT SUITS YOUR BUSINESS

One of your best marketing tools is the name of your business. A well-chosen name, whether it's your own or a fictitious one, can work very well for you. Choosing an ineffective name means you have to work much harder at marketing your business.

You as a business owner, may decide to use your own name for your business which has its own advantages and disadvantages.

Advantages

- You don't have to trademark your name because it's already yours.
- Using your own name not only improves your personal credit as your photography business grows, but it will build prestige within the community.
- It won't take long for people to recognize your name and associate it with your business.

Disadvantages

- If you choose a long and hard name to pronounce, it may make it difficult for some of your clients. As mentioned earlier, your business name is one of your marketing tools. It shouldn't be a complicated one, instead it should very clearly identify what you do in a way that will appeal to your target market.

- Doesn't match with what your business offers - If it's too obscure or cryptic, people will have no idea what your business is about. Make the name short, catchy, and memorable.

Make It Legal – After coming up with your preferred name, the next step is to check the name for legal availability. Of course, how you do this depends on what legal structure you choose for your real estate photography business. Call your local business licensing agency to get more information on registering a fictitious name. If you are a sole proprietor or corporation using the name of the owner(s), you probably will not be required to register it; however, you may still want to consider it so no one else can use that name.

Look on the internet to see if your chosen name is in use. If someone else is already using your business's name as a domain name, consider coming up with something else. Even if you have no intention of developing your own website, customers could still be confused if they search online for you.

2) Structure It Legally

You need to give some thought to your business's legal structure. Your choice can affect your financial liability, the amount of taxes you pay, and the degree of control you have over the company. It can also have an impact on your ability to raise money, attract investors, and sell the business.

BUSINESS NAME WORKSHEET

So, how do you want your business structure to be? Do you want to be your own boss or do you prefer inviting other members to form a business partnership?

What goes into choosing a legal structure? If you're starting the business by yourself, you'll be the one making all of the decisions. However, if other people are involved, you need to consider the issue of asset protection and limiting your financial liability in the event things don't go well.

1) Sole Proprietorship - Many home-based entrepreneurs prefer to be classified as sole proprietors. It's not unusual for a business owner to change that status later to include a partner or to incorporate as the business grows. The beauty of sole proprietorship is its simplicity. There's not a lot to do in the way of paperwork and filing fees. But the disadvantage of being a sole proprietor is that if anything goes wrong (i.e., you are sued or default on a loan), creditors can go after your personal assets and kick you out your business completely.

2) Partnership - When two or more people go into business together, a partnership is formed. This type of arrangement can come in handy if you want to share a real estate photography business or split hefty equipment costs. Just make sure you have a well-written agreement in place. A partnership works basically like a sole proprietorship, except the partners share in the profits, expenses, and liabilities of the business. Then you can all sit on the curb together.

3) Limited Liability Company (LLC) - This type of structure has a lot of the same elements as a partnership or corporation, but it can reduce the partners' or shareholders' potential liability.

4) Incorporation - Typically, a corporation is comprised of shareholders who elect a director, who nominates officers, who then hire employees to manage and operate the company. But it's entirely possible for a corporation to have only one shareholder and to essentially function as a sole proprietorship. The biggest advantage of forming a corporation is in the area of asset protection—making sure the assets you don't want to put into the business don't stand liable for the debt of the business. These are some of the business structures you should consider forming for a real estate photography business. You should choose one that you think works best for you. Consider what you want to do now, and where you expect to take your company.

Then choose the form that is most appropriate for your particular needs. If you decide to incorporate, you may choose to do it with the help of an attorney, or the state agencies that oversee corporations have guidelines that you can use. Even so, it's always a good idea to have a lawyer at least look over your documents before you file them, just to make sure they are complete and will allow you to function as you want.

You should remember that your choice of legal structure is not an irreversible decision; although if you're going to make a switch, it's easier to go from the simpler forms to the more sophisticated ones than the other way around. The typical pattern is to start as a sole proprietor and move up to a corporation as the business grows. But if you think you need the asset protection of a corporation from the beginning that is how you should start out.

GETTING BUSINESS LICENSES AND PERMITS

Most cities, counties and/or states require business owners to obtain licenses and permits to comply with local regulations. While you're still in the planning stages, try to find out with your local development business license department to learn what licenses and permits you will need for your real estate photography business. Also find out in what order you need to obtain them, and the procedures involved. This process will probably fall under the "least fun things to do" category because you will spend time on hold and

get the runaround, but it will save you a lot of headaches in the end.

Here are some of the real estate photography business permits that you may consider getting:

1) Occupational license or permit - This is typically required by the city (or county, if you are not within an incorporated city) for just about every business operating within its jurisdiction. License fees are essentially a tax, and the rates vary widely based on the location and type of business. As part of the application process, the licensing bureau will check to make sure there are no zoning restrictions prohibiting you from operating in your location. While you're still in the planning stage, you may find out that you can't legally operate the business you're envisioning, so give yourself time to make adjustments to your strategy before you've spent a lot of time and money trying to move in an impossible direction.

2) Fire department permit - If your business is open to the public or in a commercial location, you may be required to have a permit from the local fire department.

Most residential areas forbid signs altogether. Before you get too artistic, check regulations and secure the written approval of your landlord (if applicable) to avoid costly mistakes.

COVERING YOUR ASSETS

In the absence of a crystal ball, you can't possibly foresee each and every hazard lurking around the corner that might potentially jeopardize your livelihood. However, you can take the necessary steps to protect you and your business with adequate insurance. Sit down with an insurance agent who is familiar with your type of business, analyze your potential risks and exposures, and then purchase appropriate and sufficient coverage.

1) Homeowner's insurance - Chances are your homeowner's or renter's policy will not provide enough coverage for inventory and equipment, so you will need to add a rider to your existing policy.

2) Property insurance - This type of policy covers the building and contents (including all of the equipment in your business) in the event of damage, theft, or loss.

3) Contents insurance – When setting up a real estate photography business, contents insurance will reimburse you in the event of destruction, damage, or theft.

4) General liability insurance - This will protect you and your business from liability in the event someone—customer or an employee—sues you for personal injuries or property damage. Let's say your assistant trips over a tungsten light and burns his leg. If he decides to sue you for loss of wages and punitive damages, the cost of defending yourself could be prohibitive. That's why this type of

insurance is so important.

5) Umbrella policy - This basically covers your other insurance policies like property, casualty, and general liability in case they exceed their limits when a claim is filed.

6) Business interruption insurance - This protects you from loss of revenue in the event of property damage or loss. For example, if you were unable to conduct business because a storm caused extensive damage to your studio, you would be reimbursed for rents, taxes, and income that would have been earned during the down time.

7) Disability and health insurance – This is important as an owner of your business. No matter how young or healthy you are, there is always the possibility of a bad occurrence that could cause a serious setback. There are numerous kinds of health and disability policies that can be customized to fit your lifestyle and budget if you should ever become sick, injured, or disabled.

Unfortunately, there is not a one-plan-fits-all insurance policy. But a qualified insurance agent can help you anticipate unforeseen events, evaluate your risks, and determine which ones you need to insure against.

CHAPTER 3
STRATEGIZING YOUR BUSINESS LOCATION

One of the main attractions of starting a real estate photography business is that you can start small. But whether you operate from the comfort of your own home or run your business from a commercial location, you need a well-secured place to store your equipment, you need to track your progress and inventory, and you'll need the right supplies to set up business. The ideal location for your business depends on how much equipment and cash you have to start with, and what are your specific goals. Depending on your capital availability, you basically have two choices to set up your job. These are home-based or a commercial location. If you opt for the latter, you'll have some additional choices to make.

SETTING UP YOUR REAL ESTATE PHOTOGRAPHY BUSINESS AT HOME

With the money in your pocket, you can start as a home-based real estate photographer. Choosing the location to set up your business is a personal choice, others start at home only to be later faced with the need to expand their operation into bigger quarters. Still, others set up their studio in a commercial location at the onset or plan to do so as soon as they have sufficient revenue.

With adequate planning, a real estate photography business can be operated from any type of habitat. A poor location choice can be an expensive mistake that is difficult to rectify in the future.

MERITS OF SETTING UP YOUR BUSINESS AT HOME

1) Low startup cost - One of the key benefits of setting up a home-based real estate photography business is that it considerably lessens the amount of start-up and opening operating capital that you will need.

2) Low expenditures – Since you do not involve traveling costs and other expenses you could have incurred in another business location, you are able to spare some cash for your savings.

However, there's more to consider than simply the up-front cash. You need to be conveniently located so your clients can find you if necessary, and so you can get to them or to other places you need to go without spending an excessive amount of time traveling.

DISADVANTAGES OF SETTING UP YOUR BUSINESS AT HOME

1) Limited space causes inconveniences - Do you have a separate room available for your business, or will you have to do paperwork on a corner of the dining room table? Do you have adequate storage for equipment and supplies? Many photographers who work from

home say that having enough storage space is one of their biggest challenges.

2) Lack of privacy - You will find it helpful to separate your work area from the rest of the house so you can have privacy when you're working and get away from "the office" when you're not.

SETTING UP YOUR REAL ESTATE PHOTOGRAPHY BUSINESS AT A COMMERCIAL LOCATION

This is ideal since you will have enough space to keep all of your working equipment safe and secure.

Unlike home-based business, setting your business in a commercial location will incur more opening capital. When looking at commercial locations, your choice should be guided largely by the specific services you want to provide and the market you want to reach. Keep in mind that buying or renting a facility that can be converted to accommodate your needs will usually be much more economical than building from the ground up.

Before investing in a commercial facility, be sure the surrounding market is favorable for your business and the location is consistent with your style and image. Will your clients be comfortable coming there? Is the facility accessible to people with disabilities? If you're on a busy street, how easy is it for cars to get in and out of the parking lot? These are some of the questions that you should be

asking yourself.

CHAPTER 4

CHOOSING THE RIGHT KIND OF INDIVIDUAL TO BUILD YOUR WINNING TEAM

As an ambitious person with an aim to start up a real estate photography business, you may be the boss, but you can't be expected to know everything. There are going to be times and situations when you'll need to turn to other professionals for information and assistance. Now is the time to go ahead and establish relationships with these professionals before you get into a crisis situation.

To look for a professional service provider, ask friends and associates for recommendations. You might also check with your local chamber of commerce or trade association for referrals. Find people who understand your industry and specific business and appear eager to work with you. Keep in mind that you are going to have a personal relationship with these people, so it's important that you feel at ease with them. If you hit a snag, they will be the ones who'll help to bail you out.

So check them out with the Better Business Bureau and the appropriate state licensing agency before committing yourself.

The professional service providers you're likely to need to include in your real estate photography business:

1) Look for a good Accountant - Whether directly or indirectly, your accountant will most likely have the greatest impact on the success or failure of your business. A good accountant will always be aware of the ever-changing tax laws and how they apply to your business. They can counsel you on tax issues if you are forming a corporation as well as advise what types of business deductions you are eligible for. Your accountant can assist in charting future actions based on past performance, help you organize statistical data, and advise you on your overall financial strategy with matters related to your business goals.

2) Look for a good Attorney - Look for a lawyer who practices in the area of business law, has a good reputation, and values your patronage. Interview several attorneys and choose one with whom you feel comfortable. There is usually no charge for an initial consultation, but make sure to clarify this before making an appointment. Good attorneys don't come cheap, so you'll also want to establish the fee schedule ahead of time and get your agreement in writing. Once you have retained an attorney, let him or her review all contracts, leases, letters of intent, and other legal documents before you sign them. He or she can also help you collect bad debts and establish personnel policies and procedures. Whenever you are unsure of the legal ramifications of any situation, call your attorney

immediately.

3) Look for a good Insurance agent - A good independent insurance agent can assist you with all aspects of your business insurance, from general liability to workers' compensation, and probably even handle your personal lines as well. Look for an agent who works with a wide range of insurers and understands your particular business. There are many different types of coverage. Your agent should be willing to discuss the various details while helping you determine the most appropriate coverage. He should also help you understand the degree of risk you are taking and what remedies are available to minimize risks. Even more importantly, your agent should assist with expediting any claims that may arise.

4) Look for a good Banker - In addition to a business bank account, you should have a good relationship with a banker. The bank you've always done your personal banking with may not necessarily be the best bank for your business. Talk to several bankers before making a decision on where to place your business.

Maintain your relationship with your banker by reviewing your accounts periodically and making sure the services you use are the most appropriate ones for your current situation. Ask for advice if you have financial questions or problems. When you need a loan or a bank reference to provide to creditors, the relationship you've established will work in your favor.

5) Other Experts - As your real estate photography business grows, you may find the need to seek the services of other types of professionals in various related fields. A business consultant can help you evaluate your business plan; a marketing consultant can assist you with marketing strategies; a human resources consultant can teach you how to avoid costly mistakes when you are ready to hire employees. There is also the computer expert who can help you maintain, troubleshoot, and expand your computer system as needed, while a web designer can develop a professional looking site for your business. No matter how good you are at what you do, chances are you can't do it all. Ensure that you find different ways to network and get in touch with professionals who can help make your business a success. You should surround yourself with advisors and experts in particular areas who provide knowledge and information to help you make decisions. Savvy small-business owners use a similar strategy. This frees them up to focus on building and growing their respective companies.

BASIC REAL ESTATE PHOTOGRAPHY BUSINESS EQUIPMENT FOR A BEGINNER

A small real estate photography business can be started with less equipment depending on how large you want your business to be. You should at least have some things to consider and decide how they work in relation to your own goals and growth strategy.

As an entrepreneur, you may be lured into buying certain office equipment which may in the long run turn out to be unnecessary. It's easy to get carried away when you're surrounded by an abundance of clever gadgets.

1) Computer and Photo Printer - A computer with a color photo printer is absolutely essential for any business and especially photography. In addition to editing and producing images, it can help you manage bookkeeping and inventory control tasks, maintain client records, create a website, and produce marketing materials.

2) Software - Think of software as your computers "brains," the instructions that tell your computer how to do what you need it to do. There are many types of programs on the market such as Photoshop that edit, enhance, organize, and print images. There are also a number of systems to handle your accounting, inventory, client information management, and other administrative requirements. The software can be a significant investment, so do a careful analysis before making a final decision.

3) Modem - This goes along with the computer because modems provide essential access to the internet. Invest in the fastest cable modem or DSL that your budget will allow to accommodate the size and volume of images you will be transmitting.

If your office has a large volume of outgoing mail, consider leasing a postage meter. These instruments allow you to pay for postage in advance and print the exact amount on the mailing piece when it is used. Meters also provide a "big company" professional image, and are more convenient than stamps and can save you money in a number of ways.

4) Data and Equipment Protection - In the event of a power failure or brownout, you'll need an uninterruptible power supply to keep your computer from going down, and a surge protector to protect your system from power surges. You'll also need a data backup system that allows you to copy the information from your computer to another location for safe storage. This is extremely important for digital photographers who have hundreds of images stored on their computers.

5) Postage Scale - A postage scale is a valuable investment for business owners because it takes the guesswork out of calculating postage and will quickly pay for itself.

6) Photocopier - The photocopier is a fixture of the modern office and can be very useful to even the smallest business. In addition to making copies for clients, it will also be handy for copying invoices, checks, schedules, marketing materials, etc.

7) Fax Machine - As with a photocopier, the larger your operation,

the greater the chance that you'll need fax capabilities. Although you can add a fax card to your computer, it must be on to send or receive faxes, and the transmission may interrupt other work. A stand-alone machine with a dedicated phone line may be a better investment.

8) Paper Shredder - In response to a growing concern for privacy and the need to recycle and conserve space in landfills, shredders are becoming increasingly common in both homes and offices. They allow you to efficiently destroy incoming unsolicited direct mail as well as sensitive internal documents, such as old client files and financial papers before they are discarded.

9) Shelving - Most business owners will tell you that having shelves installed on the walls of your office is essential to keeping inventory and supplies organized and within easy reach. You can also purchase storage shelves on wheels or a shelving unit that comes as one large piece of furniture.

CHAPTER 5
TAKING REAL ESTATE PICTURES WITH DIGITAL PHOTOGRAPHY

UNDERSTANDING DIGITAL PHOTOGRAPHY

Let's go an extra mile and take a more objective approach and try to understand what digital photography is all about.

A simple definition would coin it as the taking or manipulation of photographs that are stored as digital files. You can take the picture directly by the use of a digital camera, capture a frame from a video, or scan a photograph. It does not matter, provided the image you are dealing with is in digital form.

The master and primary tool of the digital world is the digital camera. It uses an array of electronic photo detectors in order for the lens to focus on what to capture. The image is then stored on a memory card on the digital camera. It does not use photographic film which is common with older photography. While on the memory card, the image can be transferred to a computer or any other digital device

This, in essence, creates the main separation from analogue photography and digital photography. In the past, the only way in

which you could process photographic film was by developing it. With digital photographs, you can copy them to other storage devices, manipulate or enhance them, and if possible, combine a couple of images to create a mash-up.

The digital photographs are represented as bitmaps. While in this format, the photograph can be edited as you please.
You can add a number of effects by use of image enhancing software that we shall be looking at later on. These effects are meant to enhance its look and make it more appealing.

HOW THIS DIGITAL CAMERA WORKS

While digital cameras have many similar characteristics to old film cameras in that they use a lens and a combination of aperture and shutter speed to produce an exposure, what goes on inside is radically different. Unusually in these days of ever increasing efficiency, the move from film to digital actually introduces an extra stage in the image making process. In a film camera, the light entered the lens and exposed the film inside. The chemicals on it reacted and the basic image was formed (it still needed to go in the developing tank but that's neither here nor there for our purpose). The film acted as both image creator and storage device.

In a digital camera, the light enters the lens and strikes a computer chip known as the Charged Coupled Device (CCD) or the

Complementary Metal Oxide Semiconductor (CMOS) chip. These are two similar technologies that work the same way to produce the digital image. It used to be that all DSLR cameras used CCDs because they gave sharper results, but CMOS technology has improved significantly so that these days, the fashion is to use CCD chips in compact cameras and CMOS chips in DSLRs. The CMOS chip has lower noise which is digital imperfections that are detailed further on. This makes it ideal for cameras where absolute quality is the prime concern.

The CCD or CMOS chip consists of rows and columns of light sensitive diodes or photo sites, tightly packed together.

Light hits the diodes and is converted into a digital charge by the analog to digital converter. The longer the shutter of the lens is left open, the more light comes in, the greater the charge in the diodes and the higher the resulting value that is recorded. This is the brightness of the image which is formed in shades of grey, from pure black to pure white.

Over the top of the CCD/CMOS sits a color filter array (CFA). There are two different types of filters available at the moment, and variations on one of them. The most common is the Bayer filter which has a mosaic pattern of green, red, and blue receptors. They are arranged in a pattern so that for every four diode areas there are two green, one blue, and one red receptor area. As the light passes

through the filter, it registers in the receptors and sets the color for that particular area of the image.

As you can probably guess, this means that the green sensing ability of the chip is 50% accurate and the red and blue areas are only 25% accurate. However, few colors are 100% of these primaries, so it isn't the case that there are lots of unrecorded areas. The built-in computer of digital cameras analyzes the spread of all the color values and fills in the gaps according to what type of image it is. This process is known as demosaicing. In this way, the color element of the picture is created. The color filter here has three separate layers, one for each primary color. This creates more accurate color rendition as theoretically, each diode area now can now record each specific color.

So now we have a mass of digital values that represent the picture. This is the raw data and it needs to be stored somewhere. Initially, it goes into an internal memory buffer so that the CCD/CMOS can be cleared and the camera is ready to take the next picture. The bigger the memory buffer, the more pictures you can shoot quickly.

From the memory buffer the image data needs to be saved into permanent memory which is usually a removable memory card (it can also be an internal memory). The speed in which the camera can save the image from the internal buffer to the memory card dictates the overall shooting rate. A DSLR will have a bigger buffer and

faster write speeds, and so can be used to shoot more pictures, faster, than a compact camera. The exception to this is the new range of Casio high-speed EXILIM compact cameras that can shoot high-resolution images at DSLR speeds.

KNOW THE DIFFERENCE IN RESOLUTION

Compared to the film photographs, the digital photographs come with a slightly lower resolution. This is not to mean that they are of poor quality because you will hardly note the difference when placed side by side. Furthermore, the low resolution can be attributed to the fact that the digital photos are mainly used on the internet. The low resolution makes it easy for everyone to see it through the internet and to download them.

The popularity of digital photography has risen fast and steady over the years. This type of photography has affected the industry in a very big way. There are as many gains as there are losses. The loss comes in the form of certain complementary companies having to close shop or downsize the number of workers.

It Takes a Camera and a Photographer to Make an Awesome Picture

Contrary to popular belief, a higher number of megapixels does not always equal to a great picture. It takes time, practice, and dedication. If you are considering buying the latest model of digital

camera, it will be meaningless if you do not have the expertise to use it.

What this means is that it is the photographer who makes good photography and not the camera. It is not uncommon to find bad pictures taken by a state of the art camera and breath-taking photos taken by a mobile camera phone with fewer megapixels. There are many file formats for digital photography. A good format enables compression of the files, which makes a transmission on the internet faster.

During production, digital photography may be faster and cheap but it is not easy at all. Coming up with a quality product requires great expertise.

Simple Things Every Digital Photographer Must Know

A picture is worth a thousand words. This is true. What we forget to add is that a bad picture will not tell the same story as a good picture. Pictures freeze moments. How well that can be achieved depends on how well you have mastered your art.
It is all about the light

The amount of light could either make your picture great or destroy it completely. Mastering the art of balancing the light is what separates a pro from a beginner. This is the reason why most

photographers will reschedule their photo shoots in case there is too much sunlight. You will find a majority of photographers preferring to take their photos during the early morning hours and late in the evening when the sun is setting.

Direct sunlight will always result in the production of sharp shadows and it also spoils the picture. As a digital photographer, you need to understand how to position yourself in a way that the direct sunlight is no longer a hindrance. Knowing how to use the flash could make this very easy. In cases where the background is already bright, the flash helps in lighting the foreground thus eliminating the shadows.

Know your camera

There is no need in having a fancy digital camera that you hardly know anything about. Digital cameras continue to be produced by the day. There is always a new invention with every passing year. The difference is always in the features offered by the camera. These features if utilized properly will make photo shooting for you very easy.

A feature such as autofocus is invaluable once you understand how it works. It will help you do away with instances where backgrounds of pictures are more profound than the subject. This and many other features may just happen to be the magic that epic pictures are made of.

Whenever you buy a new digital camera, do not just throw away the manual unless you have read and understood most of it. Ensure that you read the instructions in the manual.

It will take some time before you finish going through the manual. Don't rush. Take your time to do it right.
Move close enough

The little details are what make up a good picture. Moving close enough to your subject will enable you to capture every single detail.

Rule of thirds

Apparently, not even the latest of technologies could write off this ancient technique. This technique entails dividing your focus area into thirds. While looking into the lens, you will then place the subject around the area where the fractions intersect. When you take the picture, everything will just turn out as it is supposed to. The background, foreground, and the object will all be perfect. This principle should serve as a guiding tool when taking your pictures but should not be used almost every single time.

Choosing Your Cameras

As we mentioned earlier, a top-notch camera does not guarantee

high-quality pictures. Two people can possess the same camera but the resulting quality of pictures could end up being very different. The camera does not take pictures itself. However, it is always worth it to have a good camera if you can afford it. Before making that choice, there are several things that you will need to consider.

What do you need?

The world of photography is very diverse. Many photographers specialize in many different fields. With this diverse need comes different types of digital cameras to satisfy those needs. The type of environment you will be operating in also matters in addition to the kind of features you want the camera to have. Lastly, your level of experience has to be considered too.

Point and Shoot

The point and shoot camera will be the best choice if you are just a novice who is starting to explore the world of photography. It is not complicated like the DSLR and it is also very affordable. The DSLR is a better quality camera which requires proper care and maintenance. They are bigger and heavier than the point and shoot cameras. The important features of the DSLR is that they have the largest image sensors, fast focus speeds, and a wide variety of lenses. All of these come at a higher price. You will also need the experience to better handle them.

The zoom and big sensor factor

As far as zooming is concerned, you will be presented with the choice of the optical or the digital zoom. Between the two, the optical zoom is a better choice as it produces better quality pictures. The digital zoom has the inclination of enlarging the picture and making it more pixilated. The zoom ratio is significant since it determines the angle coverage of your camera. A camera that can cover wide angle shots is better, especially for taking family portraits.

These three factors should help narrow down your search to a manageable number. What you should do next is visit stores that sell the digital cameras and ask to test them out. Eventually, you will be able to find a camera that you feel suits you best.

The flash

Having a flash on your camera is no longer a necessity. It is mandatory. Choosing detachable flash units will help you illuminate each scene appropriately before snapping the shutter. Even though most of the professional photo shoots would include backup lighting, a camera with an on board flash will always take better photos in low light areas than one without.

You, however, have to remember that having a flash mounted onto your camera does not mean that you should always use it. There are specific occasions when you must never use your flash. For instance, when taking photos including highly reflective surfaces, for instance, mirrors or shiny surfaces, using a flash will reflect more light hence creating a 'burn' effect on the photo.

Budget

In the end, it will come down to the amount that you are ready to spend on the camera. With the wide variety available, you should be able to get a good camera that is within your financial means. Spending large sums of money on a product that only differs slightly in terms of megapixels is not a very good idea.

Knowing Your Camera Lenses

A good DSLR (digital single-lens reflex) will push your skill and finesse beyond the limits. In essence, DSLR cameras contain removable lenses meaning you can always attach the lens you want for different pictures. The basal power of this type of a camera is in the fact that you can always take different pictures in different settings provided you have the right lens.

With this, you do not have to invest in cameras with strong lenses or impressive software processing to cover up for the changes in

performance. With a DSLR, you can start simple with the cheapest lenses in the market before moving on to more expensive and impressive lenses.

So far, nothing answers the question at hand. If you can afford to invest in the compact and surprisingly effective cameras in the market that aren't DSLR but can still change lenses, then you might be good to go. Either way, you still must know how to differentiate your lenses and what to consider before buying an add-on lens.

Mount surfaces

Cameras have different mount surfaces. Most brands would love to keep their mount surfaces different from competitors meaning that there are no universal lenses unless you first use an adapter to recalibrate your mount point. Buying your brand's lens is the best way to get around this.

Focal lengths

The kind of photography you engage in should determine your lens' focal length. The focal length determines how much a camera can zoom. It also has an impact on the overall cost of the camera. For normal close up photos like in the case of real estate photos, you could make do with 50mm or 75mm lenses.

DISCERNING THE CAMERAS FORMATS

Many of you reading this will already have invested in a camera or may be considering purchasing one. As you know, there are many different camera systems available, some of which are more suited to studio work. There are also some less commonly known, yet extremely useful, pieces of equipment that could prove to be extremely beneficial in your work.

This is not meant to be a guide on which brand of camera you should purchase, but instead will offer some guidance as to what type of camera is more suitable for different types of real estate photography, plus some advice as to what is available and some of the differences between the varying camera formats.

CHAPTER 6

BASIC RAW PROCESSING

The word processing has been associated with photography since its existence. For many years it referred primarily to the processing of exposed film into negatives, which was done in temperature controlled tanks filled with chemicals to process the film and water to clean it. Once the negative was produced, the photographer used to process the photographs by placing the negatives onto an enlarger, thus exposing the light sensitive paper to the light passing through the negative. The paper was then developed to produce the image, using developer, stop-bath and then a fixer. This was known as print processing. Generally speaking, once the film became a negative the ability to 'edit and retouch' began, with various darkroom techniques such as dodge and burn, although the choice of film and chemicals used to process the film could hugely affect the finished image.

Things have not changed much in the digital age, except that we now work with digital negatives or RAW files. To some degree, the task of post-processing images has become hugely more accessible and affordable, if not completely automated on some occasions. As most photographers no longer process film, the term post-processing has generally become accepted as anything that manipulates or changes the RAW file once the shutter has been fired.

Professional and experienced photographers tend not to rely on post processing techniques to save an image that does not succeed; however, some post processing is inevitable and to some degree expected in today's market.

To this end, this chapter is a very brief and basic insight into how to process your RAW files using the industry standard software, Adobe Camera Raw (ACR).

RAW – THE DIGITAL NEGATIVE

Many people new to the world of digital photography fail to appreciate that their standard compact camera processes photographs in-camera. Any camera that shoots in JPEG or even TIFF format will process the images to some degree and then compress them into one of the recognized file formats.

JPEG may be convenient, allowing you to get many exposures on a single storage card; however, it also massively impacts on flexibility and image quality, introducing unwanted artifacts, color casts, and tonal curves. RAW, on the other hand, undergoes no or little in-camera processing and needs importing into the camera manufacturer's proprietary software or a recognized RAW converter, such as Adobe Camera Raw, to be processed.

Shooting in RAW allows the photographer to process the images by way of fine-tuning and other adjustments prior to editing. The amount of adjustment that can be made to a digital negative prior to editing is huge, ranging from exposure to vignetting, so it is worth spending a little time exploring the various RAW processors on the market and the effects that you can achieve with them.

OTHER RAW CAPTURE UTILITIES

Note: For simplicity, I am referencing Adobe Camera Raw, as it is the most popular and widely available of RAW capture utilities. However, most major camera manufacturers, plus several third-party software developers, produce their own software to process RAW files. The techniques utilized here may be applied in the majority of RAW capture software; however, the tools and menus will vary.

There are a few useful basic tools and visuals you should be aware of when editing digital negatives that are particularly helpful when fine-tuning color balance, exposure, and even reducing digital noise. These techniques are quick, basic, and simple adjustments that will have you improving your images in minutes.

Histogram

The histogram will give you an instant visual graph of all the tonal information in your image. It will instantly tell you if you have a

clipped shadow detail or a highlight detail. It will also give you a visual indication as to where the majority of the image data resides, such as the shadows, mid-tones or high-lights. The histogram is something that many new photographers ignore; however, it can be a very useful tool when judging exposure or even to ascertain if you are clipping certain colors.

When looking at the histogram, you will see shadow detail to the left, mid-tones in the middle and highlights to the right. As a rule of thumb, if your histogram is more dominant to the right, then your image is possibly overexposed.

On the other hand, if your histogram is more dominant to the left, then it is possible that your image is underexposed.

It is important to remember that it is only a guide and you will find that shooting on dark and light backgrounds may push the histogram either way, yet your photograph will be properly exposed.

If you are seeing a large spike in the histogram it is usually a sign of clipping (where image data is being lost). It may be that the dynamic range of the scene is wider than your camera can capture; however, small adjustments to exposure will usually help.

TEMPERATURE VS TINT

Remember: Adjusting the Temperature slider will make the photograph warmer or cooler, whereas the Tint slider compensates for the green or magenta tint.

Exposure Slider

It is always preferable to use a light meter and expose your images properly at the time of the shooting. No amount of processing can beat a properly exposed photograph. However, there are of course times when exposure may not be as accurate as we had hoped for. It is common, even in studio photography and can be affected by subjects moving in and out of the light source or even by variances in power from cheaper flash heads. As you would expect, there are a few processing tweaks we can do when working with RAW files, but like everything, there is a caveat.

The Exposure slider essentially elongates the histogram and increases the clipping point of the highlights. Moving the slider to the right will lighten the image and moving it to the left will darken the image. The Exposure slider basically ascertains where the highlight data will clip, and then converts the clipped highlight value to 255. The remaining darker tones are lightened, and the histogram elongated and smoothed out.

All of this flexibility with exposure sounds great, but it is limited and its flexibility will depend entirely on the camera system you are

using and the quality and bit depth of the image it produces. For the most part, increases above +1.00 can begin to introduce noise and artifacts into your photograph. You may also find that it causes shadow detail to break up and become posterized. The higher the ISO used, the more noticeable these artifacts can become. Higher-end 35mm systems and medium-format digital can be pushed further without necessarily experiencing any degradation of image quality.

Recovery Slider

Traditionally, it is the highlight information in digital photography that is the most susceptible to being blown. This is in contrast to film, where there is less latitude within the shadows. The studio, for the most part, is a controlled environment, where lighting can be adjusted to ensure that photographers achieve a properly exposed photograph without blowing the highlights; yet there are occasions when highlights are clipped, due to reflective surfaces, lighting and positioning constraints, or even movement. The Recovery slider can help you retrieve some or all of the lost highlight data, and this is one of the huge benefits of shooting RAW.

You will find that moving the Recovery slider to the right will begin to slowly recover the highlights and as you move it, you will notice the highlight information on the histogram moving to the left and slowly bunching with the mid-tones. It is important to keep a close eye on the rest of the image, as pushing the slider too far will slowly

begin to affect all of the lighter tones and can on some occasions make some highlights appear grey. Using the Recovery slider in conjunction with the Exposure slider will increase the rate of highlight recovery and retrieve most highlight data without the introduction of artifacts. It is an extremely useful tool and it is possible to retrieve up to two f stops of information, but don't expect it to perform miracles!

Fill Slider

The Fill slider behaves like an artificial fill light. As you move the slider to the right you will see from the histogram how it will lift the shadow and mid-tone detail in the image, whilst the highlight detail remains stationary. It is particularly useful when you want to lift a small amount of shadow detail.

Moving the slider too far to the right will begin to produce some unusual effects and will begin to make a photograph look as if it is solarized. Despite being a useful tool, it is no replacement for a properly positioned and metered fill light and is best when used sparingly.

Black Slider

True to its name, this slider adjusts the darkest parts of the image, by setting a new clipping point for the shadows. It is a useful tool for

tackling slight overexposure or mild haze as it elongates the histogram, pulling it down to the left whilst leaving the highlights intact and increasing the contrast within the shadows. The Black slider can be used to complement adjustments with the Fill slider if the image begins to look a little flat and lifeless.

It is worth remembering, though, that you are basically clipping the shadow detail out of the image before you export it into your editing software, so it is worth considering what further post-processing will be done and whether you could utilize some of that shadow detail later on.

Brightness Slider

Brightness should not be confused with the Exposure slider as they perform different tasks. Whereas the Exposure slider concentrates on the highlights, pushing the histogram to the right, the Brightness slider tends to concentrate on expanding the mid-tones whilst compressing the highlights. As you adjust the Brightness slider, the mid-tones push to the right, lightening the image.

Many photographers neglect the Brightness tool in favor of adding a tone curve during post processing. Yet it remains very useful when used in conjunction with the Black and Exposure slider as a way of making those final adjustments to the equally important mid-tones. Like any adjustment, it needs to be done in moderation as too much

can begin to make an image appear washed out and lacking in contrast.

Contrast Slider

Every photograph needs contrast; otherwise, it would look flat and lifeless. The task is to strike the right balance between the shadows and highlights, while keeping enough detail in the mid-tones. The Contrast slider is one of the tools I rarely use as there are many other more precise ways to add contrast. Even when processing RAW files, it is possible to increase contrast using a combination of the Black and Exposure sliders, before editing a parametric or point based tone curve. The Contrast slider basically elongates the histogram, stretching the mid-tones while compressing both the shadows and the highlights. It reality, it is the layperson's way of adding contrast and is best left for those quick fixes or batch processing contact sheets.

Clarity, Vibrance, and Saturation

These three sliders are located under the Contrast slider in Adobe Camera Raw, and they are for the professional studio photographer, as more precise adjustments can be made later on during post processing.

1) Clarity

The Clarity slider increases or decreases the contrast around the edges, which gives the impression that the image looks sharper. If you are processing high contrast black and white street photography or environmental portraits with lots of texture, then the Clarity slider when pushed to the right may prove to be very useful. If you are working with models or even family portraits, however, then it is definitely one to avoid, as it has a tendency to pick out every imperfection – definitely not what most people want, and it will double the amount of healing and cloning during post processing.

2) Vibrance

The Vibrance slider makes the image look more vibrant by way of increasing the saturation of the colors without clipping the already well-saturated areas. When pushed too far, it can make an image look rather false, as all the colors look too even, so less is definitely more. For studio work the use of the Vibrance control is limited, unless you are batch processing contact sheets, as more precise adjustments can be made during the later stages of post processing.

3) Saturation

When increased, the Saturation slider increases the color throughout an image, causing the colors that were already strong to be clipped. It can of course also decrease the color, but tends to produce a rather

flat and uninteresting black and white image. Unless you are batch processing, the Saturation slider is better left untouched, and instead an adjustment layer made in the latter stages of post processing.

DETAIL TAB

By moving along the tabs located under the histogram, you will come across the Detail Tab. By selecting this tab, you open up the options to vary the sharpening and add an element of noise reduction if necessary. Both the Sharpening and Noise Reduction sliders are very useful tools, but care needs to be taken when using them as they can introduce unwanted artifacts into the image. It is important to remember that once the RAW image has been processed and exported into your editing software it has the ability to become more destructive the more you edit. Your use of the Sharpening and Noise Reduction sliders will of course depend entirely on your given market. So if you are photographing a hundred portraits a day and then batch processing the lot, the detail tab will be ideal for your workflow.

However, if you are shooting commercially and will be editing a small number of photographs, you may wish to leave much of the sharpening to the later stages of post production, where parts of the image can be masked and the layers peeled back if necessary or adjusted to the output size and medium.

SHARPENING

Amount

As it suggests, moving the slider adjusts the strength of the sharpening. Moving the slider to the right increases the sharpening and moving it to the left decreases it. It is worth watching the image as you increase the sharpening, as too much has a tendency to produce halos and pixilation around contrasting edges. Default value is 25.

Radius

This is the area around or within a pixel where the sharpening will take effect i.e. the width of the halos. Increasing the radius basically increases the area that is sharpened, or, adjusts the size of the details that sharpening is applied to.

Using a smaller radius will allow you to sharpen smaller and more subtle parts of the image, whereas a larger radius may assist you in correcting minor motion blur. A larger radius setting will also emphasize the finer edges and at the same time enhance the softer edges. Default value is 1.0.

Detail

The Detail slider suppresses the halo effects whilst allowing you to increase the Amount of sharpening without unwanted artifacts. When the Amount and Radius sliders are at their default values, the effect of the Detail slider is fairly subtle and is useful for bringing the fine edges of hair and fabric, even when pushed to the maximum value of 100. However, multiply this with a sharp increase with the Amount slider and the effect is immediate and unpleasant, producing unwanted noise and artifacts. For studio portraits, lower detail settings are recommended.

Masking

The Masking slider affords you some control over the overall sharpening effect. The more you increase the Masking slider, the more you begin to protect the flatter tones within the image from the effects of the sharpening. Utilizing the grayscale edge mask by holding down the key will help you visualize your adjustments more clearly.

NOISE REDUCTION

Noise is caused by several factors within the camera. This can be anything from the heat generated by the sensor, in- camera processing or even exposure times.

Noise reduction (NR) is a very useful way of removing unwanted

noise from images. As a rule, noise isn't a common issue with studio photography, given that most images will be taken between 100 and 200 ISO and be correctly exposed. However, there may be occasions when you find that you need to increase your ISO to compensate for depth of field or lack of power. It is occasions such as this when underexposure is a risk and where noise can begin to creep into the shadow areas. Applying noise reduction during RAW processing and post processing is for the most part better than doing it in- camera, simply because you have greater control over the whole process and will avoid introducing unwanted artifacts at the early stages. Noise reduction is destructive and if applied during RAW processing it becomes permanent. For this reason, it is advisable to leave noise reduction until the later stages of editing, so that it may be applied selectively and peeled back when necessary.

LUMINANCE

The Luminance slider controls the type of noise we most commonly known as grain, also known as grayscale noise.

The default value in ACR is '0', so moving the slider to the right will increase the noise reduction and decrease the film grain. It is important not to increase this too much as it will begin to remove the detail. Grain is rarely an issue, adds character to an image and is even less noticeable when printing.

Luminance Detail and Luminance Contrast

Unless you are shooting at very high ISO or pushing the exposure on a much underexposed image you are unlikely to benefit too much from using these sliders.

The Luminance Detail slider controls the luminance noise threshold. On the face of it, the higher the value the more detail and noise it will return to the image, although the detail is more apparent on the edges, leaving the flatter tones looking smooth.

The Luminance Contrast slider is useful for very noisy images. When used at higher values, it will assist in preserving the contrast, but will also introduce blotches of noise and mottling.

COLOR

The Color slider default is set at 25. It is not unusual in studio photography for the default setting to be zeroed in order to preserve the original color. If you have noise in your image, moving this slider to the right will begin to remove the colored speckles that you can see in noisy images, which are normally red, purple and green, known as chroma. Increase the Color noise reduction too much and the image will become blotchy.

Color Detail

The Color Detail slider controls the color noise threshold. It is there to assist in reclaiming some of the detail removed by Color noise reduction. Pushing the slider to the right will protect finer, detailed color edges, but increase color speckling. Decreasing the amount of Color Detail will remove colored speckles at the risk of introducing color bleed.

CONCLUSION

There is plenty of money to be made with real estate photography, but there's also beautiful photography to be made, as well. It really is a great way to earn a living. It's fun, and there's just something fulfilling knowing that others are willing to pay for the photos you've taken.

This is your time now, build that confidence in you that will make you produce great real estate pictures. With the skills described in this book, you will be able to make a huge income from the photos you take of properties that are for sale.

With the help of these tips and tricks in this book, you should now have some basic knowledge to take the steps needed to get started with your real estate photography business. You should advertise your skills to real estate agents and people who are selling their homes, and tell them where to go online to see samples of your work.

Make sure you price your pictures according to similar trends in the market and pay attention to those photos that are really selling and learn from them.

Stay focused and committed to your craft and I am sure that your

real estate photography business will thrive!

Best of luck to you!

www.ingramcontent.com/pod-product-compliance
Lightning Source LLC
Chambersburg PA
CBHW071420180526
45170CB00001B/166